The Campus History Series

SOUTH PHILADELPHIA HIGH SCHOOL

FRONT COVER: The South Philadelphia High School (SPHS, or "Southern") cross-country team is seen on the front steps of the school in a photograph from the 1918 yearbook. The bond of friendship and teamwork portrayed in this picture is symbolic of the bond shared by all former students and graduates of Southern. (Courtesy of SPHS Alumni Association Archives.)

COVER BACKGROUND: The original South Philadelphia High School was built in the Norman Romanesque architectural style and served from its opening in 1907 until 1955. (Courtesy of SPHS Alumni Association Archives.)

The Campus History Series

SOUTH PHILADELPHIA HIGH SCHOOL

DR. TONY EVANGELISTO WITH CONTRIBUTIONS FROM
MARC ADELMAN, GENE ALESSANDRINI, AND CAROL EVANGELISTO

ARCADIA
PUBLISHING

Published by Arcadia Publishing
Charleston, South Carolina

Printed in the United States of America

Library of Congress Control Number: 2018933446

For all general information, please contact Arcadia Publishing:
Telephone 843-853-2070
Fax 843-853-0044
E-mail sales@arcadiapublishing.com
For customer service and orders:
Toll-Free 1-888-313-2665

Visit us on the Internet at www.arcadiapublishing.com

For the generations of families, teachers, administrators, and former students of South Philadelphia High School who have contributed to making Southern truly "the School of the Stars."

CONTENTS

ACKNOWLEDGMENTS

I wish to thank the South Philadelphia High School (SPHS) Alumni Association for its support of this project. Beginning with former presidents Sam Chatis and Thomas Sebastian and continuing through new president Joyce Garozzo, the members of the alumni association have offered continuing support in telling the story of South Philadelphia High School, "the School of the Stars."

I am also deeply appreciative of the involvement and dedication of Thomas DiRenzo, Marc Adelman, and Gene Alessandrini, who have added so many personal and illuminating insights in recounting our history. I thank Louis Lanza for providing the spark that inspired my wife, Carol, to recommend writing this book. Certainly, Erin Vosgien and Angel Hisnanick must be acknowledged for working with me in developing this project. Thank you both.

Most especially, I wish to acknowledge the inspiration and support of my wife, Carol, whose idea to write this book provided the original impetus. Her patience, understanding, insights, ideas, and sacrifices have sustained me throughout this endeavor. Needless to say, family and friends have also been a part of this journey, including my four daughters and sons-in-law (Mary and Ken Miller, Drs. Amy Evangelisto and George Mark, Christie and Whit Lee, and Laura); my grandchildren Francesca, Tyler, and Katie; my four brothers, all Southern graduates (Biagio, Gilbert, Frank, and Jim); the Giovinos (Randy, Abby, Ava, and Carly; Al, Patty, AJ, Amy, Ellie, and Audrey); and a host of friends, including Dr. Richard Farber and his wife Diane, Ebtissam Ammar, Miles Rabkin and Kris McDaid, and Drs. Don and Simona Wright.

My debt of gratitude includes two former teachers who made all the difference in my life. First, Mary Lippmann, my Latin teacher at Furness Junior High School: her caring restored in me a hope for the future at a time when my struggles were overwhelming me. She turned my life around and gave me the confidence to move forward. The second is Dr. H. Bernard Miller, former teacher at Furness and friend of Mrs. Lippmann. Bernie joined the faculty of Temple University with the Intern Teaching Program for College Graduates, later becoming its director. In that program, I benefitted from Bernie's mentorship, culminating in his becoming my advisor for my doctoral dissertation. His inspiration, guidance, and direction helped me enormously. I owe so much to him and honor him always, along with Mrs. Lippmann, in all that I do. Unless otherwise indicated, all photographs appear courtesy of the SPHS Alumni Association Archives.

INTRODUCTION

In May 2014, Louis Lanza was inducted into the South Philadelphia High School Cultural Hall of Fame along with his brother Joseph, posthumously. Lanza, a former member of the Philadelphia Orchestra, shared his virtuosity on the violin by playing "Non Ti Scordar Di Me," a beautiful Neapolitan song that translates as "Don't You Forget About Me." My wife, Carol, was moved to tears by the beauty of the song and the way in which Louis lovingly performed it. She turned to me and asked how one school could produce so many talented and exceptional people. This led to the writing of *The Stars of Southern High* (publication pending), a book focused on the myriad success stories of Southern's former students, which led to this book about Southern's history. This book is about the school itself—South Philadelphia High School—and its special place in the city of Philadelphia, the United States, and the world.

> Don't forget about me; My life is tied to you.
> I love you more and more; In my dream you stay.
> Don't forget about me; My life is tied to you.
> There's always a nest; In my heart for you.
> Don't forget about me; Don't forget about me.

These words express beautifully the power of love and of our connections with each other. The connections are varied: with family, with others, with friends, with lovers, with our neighborhoods, and even with our schools. Consider this book our way of saying "Don't You Forget About Me" as alumni of a school that we cherish so much; this book is our way of preserving the memory of a school that has given each of us so much. It is our way of saying to our school and former teachers, "We will not forget about you."

The alumni association has supported this project, and several members of the executive committee participated by adding their skills, information, and expertise: Marc Adelman, the archivist of the alumni association, Gene Alessandrini, former math teacher and math department chairperson at SPHS (nicknamed "Southern"), and Tom DiRenzo, a highly experienced writer, editor, and business manager. Their knowledge of the school and of so many of our graduates has had a marvelous effect in personalizing the saga of Southern's history. Special thanks are also extended to Sam Chatis and Tom Sebastian, former presidents of the alumni association, and to Joyce Garozzo, current president, for their support.

This book tells the remarkable story of a school that has achieved a unique and truly noteworthy place in American history. It is an urban school, serving immigrants of very modest financial means residing within boundaries established by the School District of Philadelphia. Southern is truly a public high school; it did not require entrance tests for admission, which makes the saga of Southern so remarkable.

The "voice" by which we present our profiles of Southern's stars is intended to be informal and personal, with some subjective comments and witticisms inserted occasionally. The intention of this approach is to make the reading of this book more enjoyable and satisfying. This is a repository of a "family" history—the family of South Philadelphia High School.

Dates in parentheses following a person's name indicate the year that person graduated from Southern.

All author proceeds from the sale of this book will be used to benefit South Philadelphia High School and its students.

Non ti scordar di me.
—Tony Evangelisto

One

SOUTHERN'S
EARLY HISTORY

South Philadelphia High School's proud history dates to the breaking of ground on May 30, 1905, for its construction. Former principal Matthew H. Richards provided the historical background that follows. Southern was the first district high school in Philadelphia, intended to provide job skills to a large population of immigrant children. Its original name was Southern Manual Training School. Southern also offered limited academic and commercial programs. The school opened for students on September 9, 1907, with Dr. Lemuel Whitaker as its first principal.

The first class graduated in 1910, and the growth of Southern was rapid. During 1914–1916, the building was extended to give additional space for boys and for the inclusion of girls. In 1916, the name of the school was officially changed to the South Philadelphia High School for Boys, and its counterpart was named the South Philadelphia High School for Girls, under the leadership of principal Dr. Lucy Wilson. Enrollment expanded dramatically, and additional facilities were used.

In June 1928, Dr. Whitaker retired and was succeeded by Frank C. Nieweg, the head of the Department of Languages. The school continued to expand until 4,000 boys were attending daily sessions in two shifts. When a junior high school was opened nearby, the ninth grade was withdrawn, and Southern became a three-year senior high school. Under Nieweg's direction in 1941, Southern opened one of the best public school athletic fields in the city. During World War II, a total of 1,131 of Southern's students and alumni entered military service; 129 made the supreme sacrifice. Some students left school before graduation to serve their country.

Southern feels justly proud of its graduates and former students, many of whom have made significant contributions to the city, state, and nation. Numerous "Southernites" have obtained positions of prominence in business, music, literature and journalism, law, medicine, dentistry, scholarship, and teaching. The later chapters provide a partial exploration of these remarkable individuals. There are so many Southern stars with remarkable achievements; only a few can be acknowledged here.

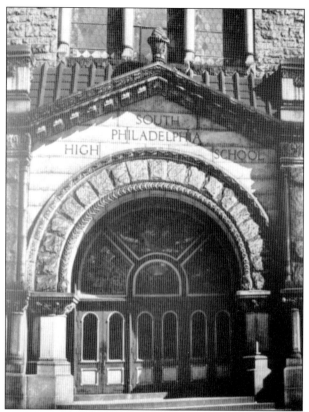

Shown at left is the entrance to Southern's original Norman Romanesque building; the entire school is seen below. The early population of immigrant children consisted largely of Jewish and Italian children who were believed to be lacking in intellectual skills and who could only work with their hands. The prodigious error of this notion was demonstrated in the person of Israel Goldstein, a student who was the first alumni scholarship winner in 1911, showing school administrators that students at Southern had great capacity for academics. He graduated from Southern at age 14, then graduated from the University of Pennsylvania at the age of 17. Goldstein became a rabbi, an author, a world-renowned spiritual leader, and founder of Brandeis University.

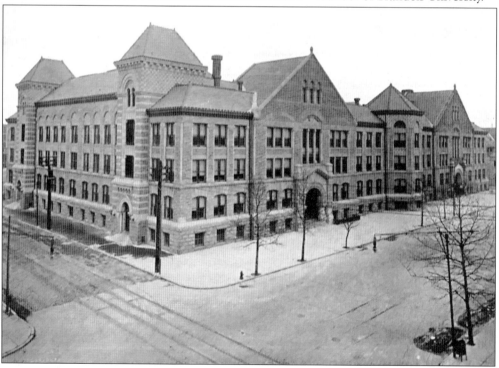

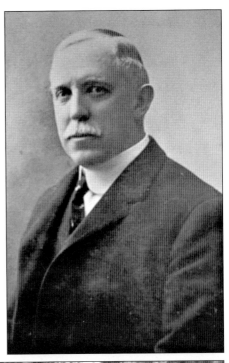

Southern's earliest leaders had impressive credentials and leadership skills. Dr. Lemuel Whitaker, right, was Southern's first principal and was succeeded by Frank C. Nieweg. They led Southern through World Wars I and II and through later world conflicts. Prominent in the culture of South Philadelphia High School is devotion to each other and determination never to forget our predecessors. Israel Goldstein, whose state historical marker is shown below, graduated from Southern and Gratz College simultaneously at age 14 and went on to receive his PhD from the University of Pennsylvania. Dr. Goldstein was executive consultant at the United Nations Founding Conference in 1947 and helped establish the National Conference of Christians and Jews.

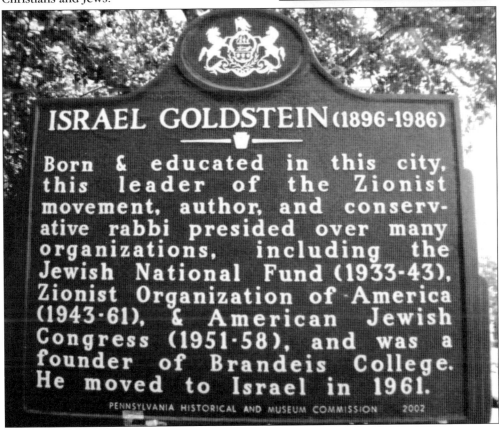

ISRAEL GOLDSTEIN (1896-1986)

Born & educated in this city, this leader of the Zionist movement, author, and conservative rabbi presided over many organizations, including the Jewish National Fund (1933-43), Zionist Organization of America (1943-61), & American Jewish Congress (1951-58), and was a founder of Brandeis College. He moved to Israel in 1961.

PENNSYLVANIA HISTORICAL AND MUSEUM COMMISSION 2002

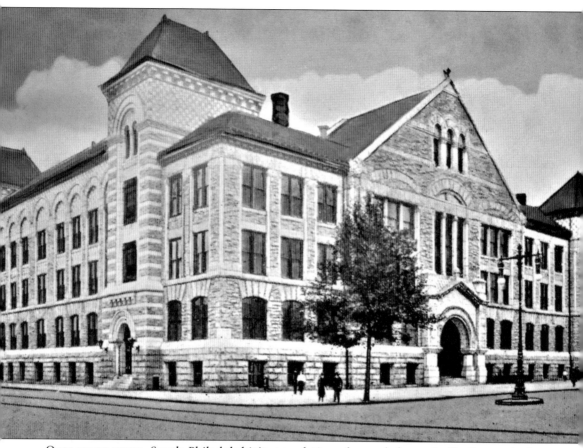

Over many years, South Philadelphia's population changed dramatically. Increasingly, African American, Hispanic American, and Asian American families moved into South Philadelphia and have become significant in Southern's community. The changing climate in Philadelphia led to the opening of charter schools, diminishing public school populations and causing school mergers. In 2013, the School Reform Commission closed 23 of Philadelphia's public schools. Edward W. Bok Technical High School was one of them. Southern is pictured here as it stood on the original school grounds.

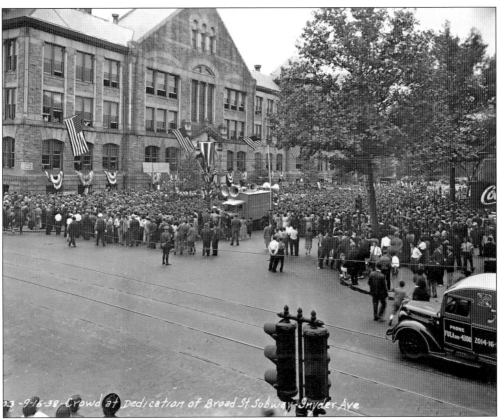

93-9-16-38-Crowd at Dedication of Broad St.Subway-Snyder-Ave.

Around the same time that Bok Tech was built, the Broad Street Subway had just been extended to Snyder Avenue at Southern's entrance; the photograph above shows the excitement of that occasion. Later, when Bok was closed, the merger with Southern presented quite a challenge to principal Otis Hackney (right). To his enormous credit, Hackney effectively handled the transition and took great pains to welcome the students from Bok.

The RED and BLACK

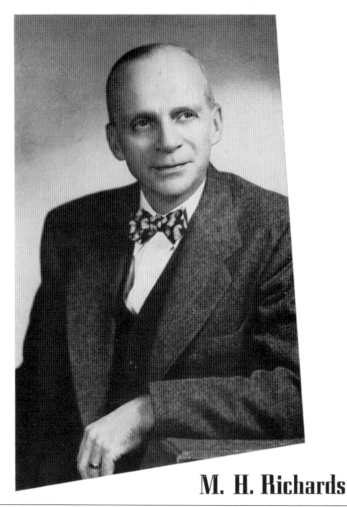

P
R
I
N
C
I
P
A
L

M. H. Richards

Emphasis on character is an ongoing theme in Southern's culture. Matthew Richards, teacher and then principal during World War II, said: "If you have built a rampart against hatred and prejudice you have done well. Let us not forget the human ramparts of the bodies of our 2700 loyal sons of Southern who have made it possible for us to carry on at home. We must be ever on the alert in the years to come to see to it that their sacrifices shall not have been in vain."

Joseph J. Rossi shared his pride for Southern's students in the 1961 yearbook *Keepsake*: "We know that Southern has made indelible impressions on the sands of time—both in its traditions and with its graduates. Southern has certainly contributed fine men and women in all fields of endeavor, such as education, religion, law, medicine, art, science, engineering, government, business, industry, theater, and entertainment. Yes, Southern graduates have done credit to their families, to their school, to their community, and to themselves."

Ben A. Farnese exclaimed in the 1978 *Keepsake*, "Looking back over the past twelve years, I'm sure that you can all identify some time, some place, or someone that has inspired you in some way. . . . I hope you have taken the time to thank all who have helped. . . . Principals, teachers, and counselors would all like to feel that they have contributed toward this end, but you have to be congratulated for your desire, energy, courage, and faith. It is my sincere hope your future will be filled with happiness and success."

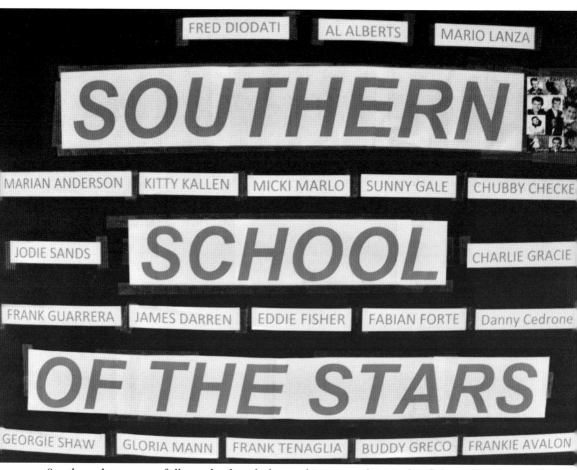

Southern has successfully evolved and changed to meet the needs of the cultural mix of South Philadelphia residents. The best testimonial to a school's success is found in the actions of former students as they take their places in the world. While Southern has been acknowledged as the School of the Stars, it is so much more. Posters created by Gene Alessandrini (1955) and Tom DiRenzo (1955) for their presentation entitled "Southern Singers" highlighted some of the stars. This poster identifies major stars who emerged from Southern's halls to entertain the world: Marian Anderson, Mario Lanza, Fred Diodati, Al Alberts, Kitty Kallen, Micki Marlo, Sunny Gale, Chubby Checker, Frank Guarrera, James Darren, Eddie Fisher, Fabian Forte, Frankie Avalon, Jodie Sands, Charlie Gracie, Georgie Shaw, and Frank Tenaglia. There is also pride in so many other former students who have contributed significantly to humanity. The South Philadelphia High School Alumni Association endeavors to recognize graduates who have gone on to achieve great success in a variety of venues. The Sports Hall of Fame and Cultural Hall of Fame honor noteworthy graduates.

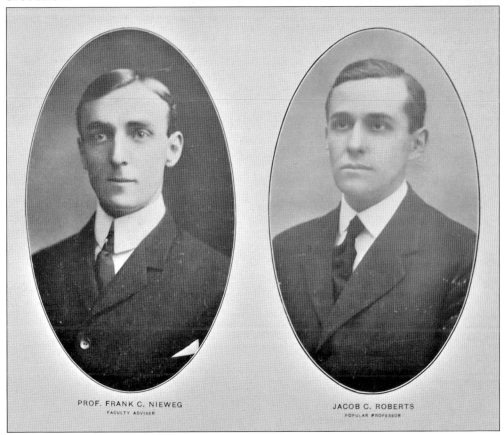

Southern's original identity is shown in the logo on the cover of an early yearbook (right); Professors Nieweg and Roberts are shown below. Frank Nieweg began as a teacher in the language arts department, rose to department head, and then succeeded Dr. Lemuel Whitaker as principal of Southern.

PROF. FRANK C. NIEWEG
FACULTY ADVISER

JACOB C. ROBERTS
POPULAR PROFESSOR

Southern has evolved over the years, starting with its establishment as a manual trades school, transforming into two separate schools for boys and girls, and then becoming a comprehensive high school, eventually absorbing the Bok Vocational-Technical High School when declining enrollments resulted in a decision to shut that school by the School District of Philadelphia. The leadership of Dr. Whitaker, right, was vital to Southern's early success; he fostered the development of skills and physical development among the students. The cross-country team is shown below at Southern's entrance in an early yearbook photograph.

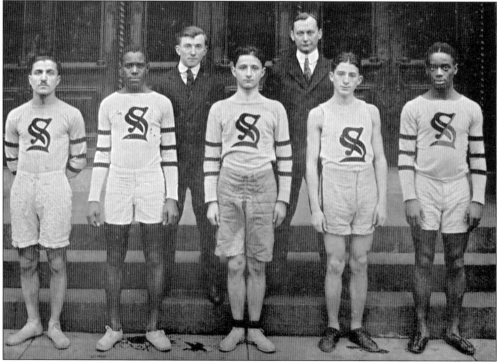

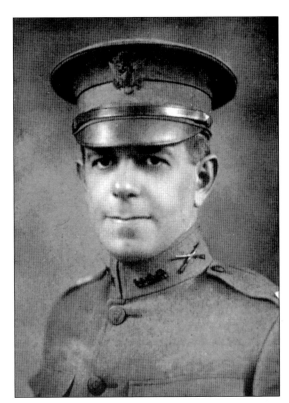

Yearbook names signaled the concerns surrounding world events. Staff members who served in the military were featured in those yearbooks. At right, teacher Lt. Frank W. Melvin was pictured in a wartime yearbook, while below is the cover of the 1940 yearbook at a troubled time in world history.

CROSSROADS

RECORD

of the

FIFTY-NINTH GRADUATING CLASS

South
Philadelphia
High School
for Boys

JUNE 1940

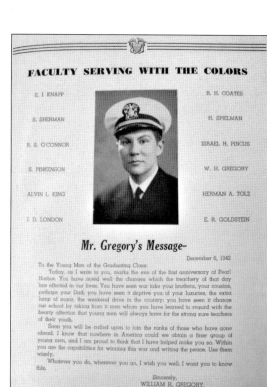

FACULTY SERVING WITH THE COLORS

E. J. KNAPP	R. H. COATES
S. SHERMAN	H. SPIELMAN
R. S. O'CONNOR	ISRAEL H. PINCUS
S. PINKENSON	W. H. GREGORY
ALVIN L. KING	HERMAN A. TOLZ
I. D. LONDON	E. R. GOLDSTEIN

Mr. Gregory's Message—

December 6, 1942

To the Young Men of the Graduating Class:

Today, as I write to you, marks the eve of the first anniversary of Pearl Harbor. You have noted well the changes which the treachery of that day has effected in our lives. You have seen war take your brothers, your cousins, perhaps your Dad; you have seen it deprive you of your luxuries, the extra lump of sugar, the weekend drive in the country; you have seen it change our school by taking from it men whom you have learned to regard with the hearty affection that young men will always have for the strong sure teachers of their youth.

Soon you will be called upon to join the ranks of those who have gone ahead. I know that nowhere in America could we obtain a finer group of young men, and I am proud to think that I have helped make you so. Within you are the capabilities for winning this war and writing the peace. Use them wisely.

Whatever you do, wherever you go, I wish you well. I want you to know this.

Sincerely,
WILLIAM H. GREGORY,
Ensign, U. S. N. R.

9

William H. Gregory's message to students (left) was presented in the 1942 yearbook among the names of others from the faculty who were serving in uniform. One of Southern's own, Ubaldo Alessandrini (below), served proudly during World War II and returned to teach at Furness Junior High School and at Southern. His nephew Gene Alessandrini also graduated from Southern, taught mathematics, and served as math department chair for many years. Many of Southern's former students served their country proudly. Two of them were featured in the HBO documentary *Band of Brothers*: William "Wild Bill" Guarnere and Edward "Babe" Heffron.

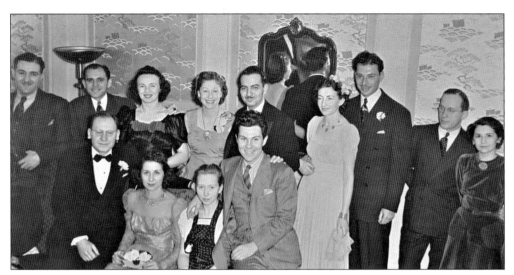

The faculty from the 1940s provided the support and guidance that Southern's students needed to face the challenges of the war. This photograph shows some of the faculty with their spouses at a senior prom; sadly, their identities could not be determined.

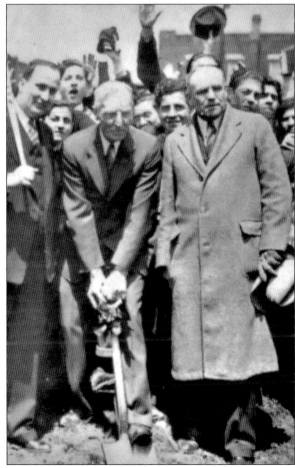

Principal Frank C. Nieweg (right) breaks ground in 1939 for athletic fields to support Southern's physical education programs. With a faculty devoted to their students and administrators providing leadership and resources, Southern contributed greatly to the war effort.

Prior to 1955, Southern consisted of a boys' school and a girls' school. Each had separate yearbooks and separate administrators. Dr. Elmer Field (left) was principal of the girls' school during the World War II era. The class photograph shown below is the girls' class of 1921, with Marian Anderson in the sixth row, second from left. Dr. Field shared his comments in the 1944 *Crossroads* yearbook: "For three years you have been living together here at Southern. . . . You have been developing a firm belief in the principles of the democratic way of life. . . . Now as you leave us. . . . hold fast to your ideals and use them as a unifying influence to bring all mankind together."

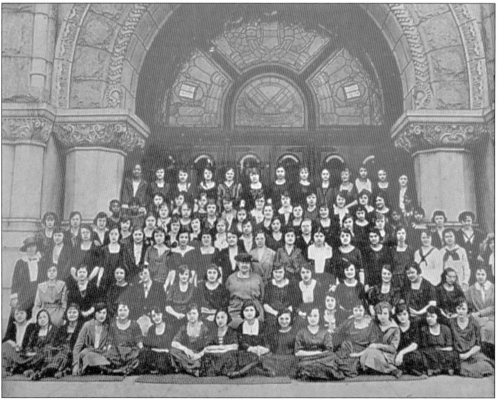

Two of the revered principals from the girls' school are shown here; Ruth Wanger at right and Dr. Lucy Wilson below. It is clear that the leadership of Wanger and Dr. Wilson imparted to their girls the essence of the school's motto, *Noblesse Oblige*. The graduating class of 1942 shared these sentiments in their *Trailblazer* yearbook: "To our Principal Miss Ruth Wanger. . . . Whose patience and understanding have meant so much to us and whose life will ever be a constant inspiration to those of us who wish to blaze new trails of service." The accomplishments of Southern's former students, both girls and boys, have clearly fulfilled the inspiration provided by the two school mottoes: *Noblesse Oblige* and "Wisdom, Industry, Initiative."

DR. LUCY WILSON

Dr. Wilson's time at Southern was one of experimental success. To her we owe our school's proud and universally famous name. Although she is long departed, the influence of her forceful personality is still felt by teachers and students alike.

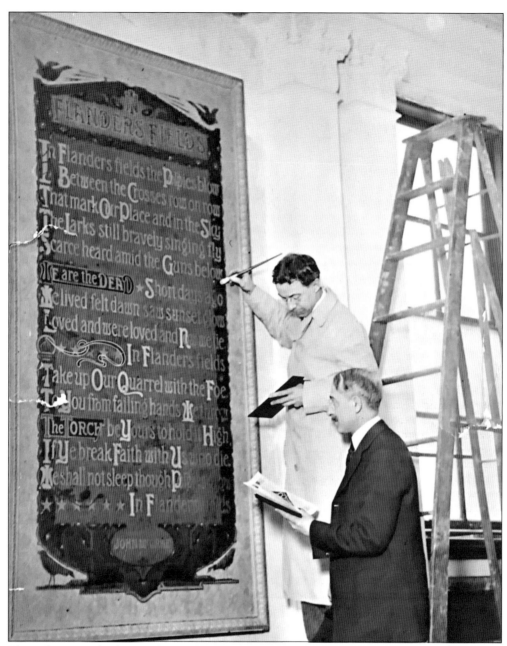

This photograph shows the painting of the mural that has been a revered part of Southern's heritage. Prof. Earl J. Early, head of the art department at Southern, is putting the finishing touches on the panel of John McCrae's famous poem "In Flanders Fields." He is assisted by Charles W. Seltzer, who is supervising the architectural features of the memorial tribute to Southern teachers and students who served in World War I. (Courtesy of the Urban Archives at Temple University.)

Two

SOUTHERN'S STARS IN ENTERTAINMENT AND THE ARTS

Music seemed to be everywhere throughout the many ethnic neighborhoods between the rivers and below South Street in the area called South Philadelphia. Many South Philadelphians excelled in playing musical instruments, and many of them "played" the greatest instrument of all: the human voice. Before there was Elvis Presley and the Beatles, Southern's Charlie Gracie blazed a path in the United States and Europe with songs like "Butterfly" and "Fabulous." Chubby Checker (Ernest Evans) taught the world how to do "The Twist." There were many others: Buddy Greco (Armando Greco), Southern's member of Frank Sinatra's Rat Pack; James Darren (James Ercolani), star of movies and television with the hit "Goodbye Cruel World;" Frank Guarrera, who had a long and distinguished career with the Metropolitan Opera; and Georgie Shaw, a popular singer. What was it like to have stars like Fabian Forte and Frankie Avalon in school around the same time? How proud did Southern students feel when the then-famous Eddie Fisher parked his limo on Broad Street and performed for them in the auditorium of the old Southern High? He brought down the house, according to Gene Alessandrini (1955), who taught math at Southern and was math department chair, and Tom DiRenzo (1955), retired marketing executive.

The list of stars is vast. In addition to those listed above, they are Marian Anderson; Mario Lanza; Al Alberts and Fred Diodati of the Four Aces; Frank Tenaglia, who sang with the Philly Pops; Joey Bishop; Joe Brown, a renowned sculptor; Frank Freda of *Diver Dan* TV fame; Frank Gasparro, the chief engraver of the US Mint; Patty Jackson, a beloved Philadelphia radio personality; Jack Klugman; Peter Mark Richman, Hollywood actor and author; Vincent Scarza, producer of Live Aid; Dick Sheeran, Philadelphia journalist and TV personality; Joseph Stefano, who wrote the screenplay for *Psycho*; and a host of classical, pop, jazz, and virtuoso instrumentalists such as Alfonso Cavaliere, Charles Earland, Joseph and Louis Lanza (violinists with the Philadelphia Orchestra), Lew Tabackin, Pat Martino, Richard DiAdamo, Sonny Troy, Vincent Penzarella, Robert Cerulli, Richie Rome, and Vincent Persichetti. The list goes on.

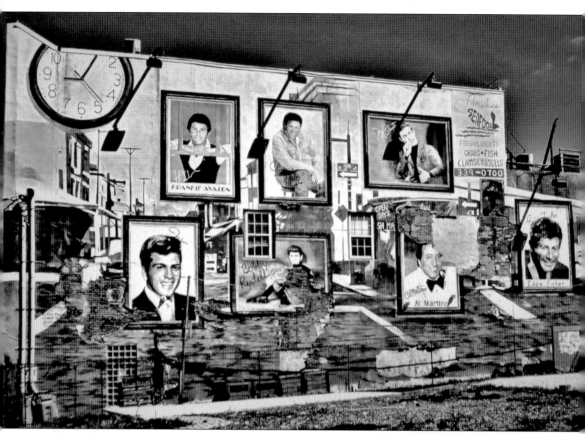

Philadelphia demonstrates its great pride in the many stars from South Philadelphia through a series of murals. Pictured is a mural at Ninth and Federal Streets near Pat's Steaks with images of noteworthy South Philadelphians. From left to right are (bottom row) Fabian, Bobby Rydell, Al Martino, and Eddie Fisher; (second row) Frankie Avalon, Chubby Checker, and Jerry Blavat. All were Southern graduates except Rydell and Blavat.

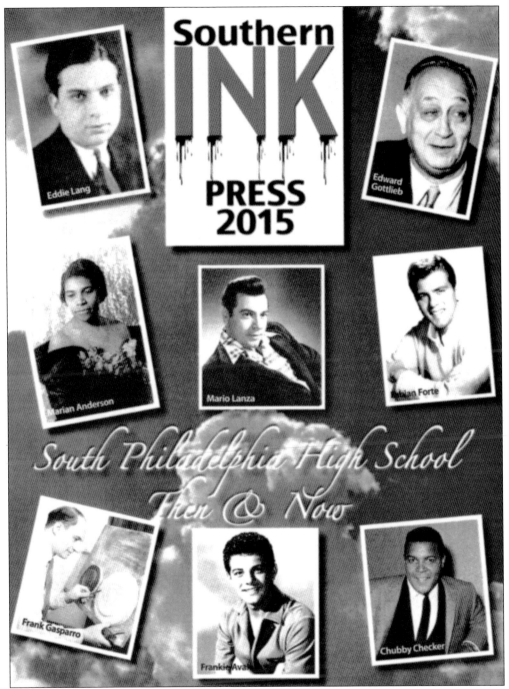

This magazine was published by graphic arts students at Southern under the guidance of Denise Powell. The cover features photographs of Eddie Lang, known as the father of jazz guitar; Eddie Gottlieb, founder of the National Basketball Association; Marian Anderson, famed contralto; Mario Lanza, star of music and movies; Fabian Forte, teen idol; Frank Gasparro, chief engraver of the US Mint; Frankie Avalon, teen idol; and Chubby Checker, singing star.

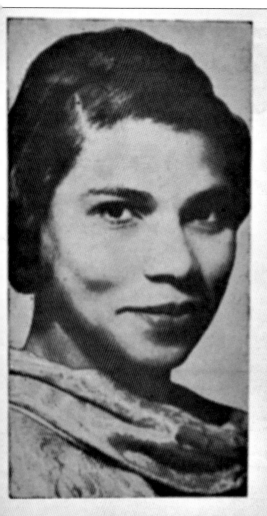

Greeting From Marian Anderson

"I regret very deeply that I shall not be able to be present at the twenty-fifth anniversary celebration. No matter where I go or how far away from home I may be, I shall always hold very dear the memory of the South Philadelphia High school for Girls. I can never forget what South Philadelphia High for Girls did for me."

MARIAN ANDERSON

Courtesy of The Bulletin

Marian Anderson graduated from Southern in 1921 and rose to international fame. Although she won many honors, including a commemorative postage stamp, she always expressed her fondness for Southern, as revealed in this message to her classmates. Anderson thrilled and inspired audiences in the United States and Europe for much of the 20th century. This Southern graduate and world-renowned contralto, who sang frequently at Southern's assemblies, is also considered to be one of the great civil rights leaders of her time. Her work included operatic arias, popular songs, and spirituals. In 1955, she became the first black performer at New York's Metropolitan Opera. She published her autobiography, *My Lord, What a Morning*, in 1956. In 1963, she sang from the steps of the Lincoln Memorial to complement Martin Luther King Jr.'s "I Have a Dream" speech. Her distinguished career brought her numerous honors, among them the US Presidential Medal of Freedom (1963), Congressional Medal (1977), Kennedy Center Honors (1978), and the Lifetime Achievement Grammy Award (1991).

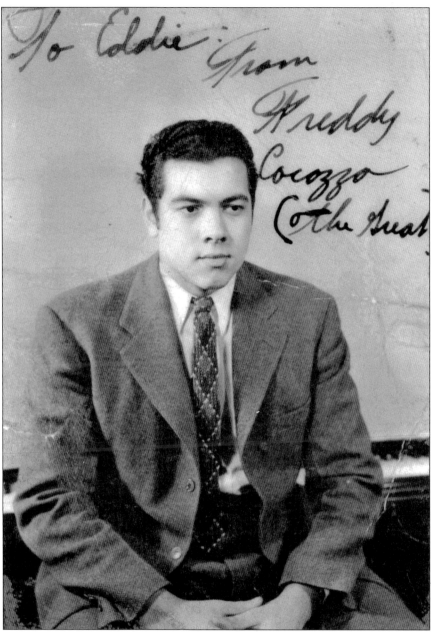

Mario Lanza, seen in this photograph provided to Southern's archives by Eddie Durso, his best friend, attended Southern in the late 1930s. He was born Alfredo Cocozza and was known as Freddy. When he became a professional entertainer, he took the masculine version of his mother's name, Maria Lanza. At age 15, he said to Eddie Durso, "I got a million dollars right here," as he grabbed his throat. "I'm going to be the greatest, most sensational tenor that ever lived." Arturo Toscanini called Lanza "the greatest voice of the twentieth century." In a concert at the Hollywood Bowl, Lanza appeared with Eugene Ormandy and the Philadelphia Orchestra, and his performance was so spectacular that Louis B. Mayer signed him to a contract to make movies with MGM. Mario Lanza has been awarded two stars on the Hollywood Walk of Fame: one for recording and one for motion pictures.

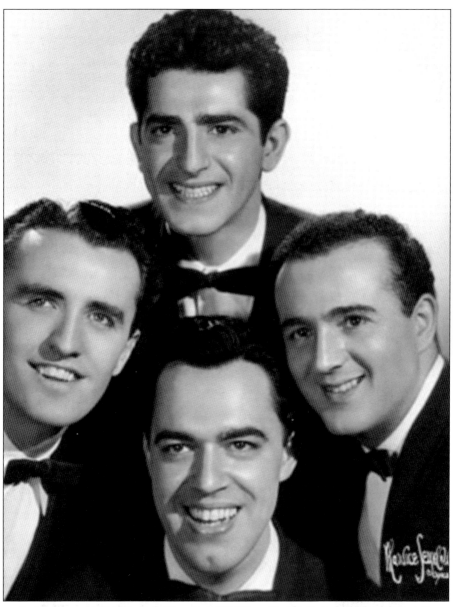

Pictured at bottom is Al "Alberts" Albertini (1940), with the Four Aces, who had three top 10 songs in 1951: "(It's No) Sin," "Tell Me Why," and "Perfidia." In 1953, they had two top 10 hits: "The Gang that Sang Heart of My Heart" and "Stranger in Paradise." More hits followed, with "Melody of Love," "Mr. Sandman," and "Three Coins in the Fountain" all reaching number one. "Love Is a Many-Splendored Thing" was another number-one; it won the Academy Award for best song. Fred Diodati replaced Alberts as lead singer in 1956. A successful contemporary was Buddy Greco (Armando Greco) who attended Southern in the 1940s. Greco recorded "Ooh Look-a-There, Ain't She Pretty," which became a major hit. Benny Goodman hired him as a pianist-vocalist-arranger for his band, and he toured the world with them. Greco's vocals are part of some of Goodman's most successful records. He has been honored with a plaque on the Philadelphia Music Alliance's Walk of Fame and a Golden Palm Star on the Palm Springs Walk of Stars.

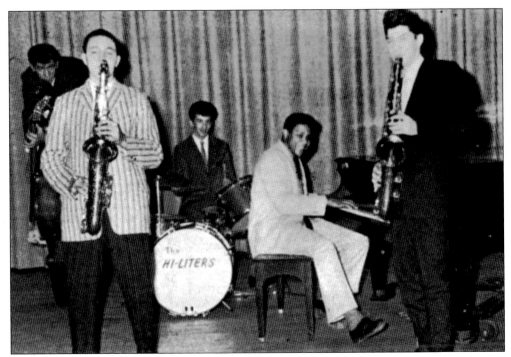

For many years, Southern High staged a yearly event called Stunt Nite. This showcased the talents of students who have gone on to great success in their careers, including Eddie Fisher and Charlie Gracie. Pictured above is Ernie Evans (better known as Chubby Checker) at the piano with his group performing at Stunt Nite. He took the name "Chubby Checker" to acknowledge his musical idol Fats Domino, signed a contract with Cameo-Parkway Records, and quickly became a bright star. He has entertained audiences around the world with exuberance and positive energy. He has had many hits, with "The Twist" and "Pony Time" reaching number one on *Billboard* magazine's rankings. The Rock and Roll Hall of Fame rewarded him with a special award presentation. Also pictured is Charlie Earland on saxophone, another world-renowned performer.

ALL SHOOK UP

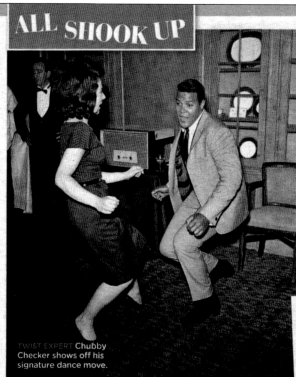

TWIST EXPERT Chubby Checker shows off his signature dance move.

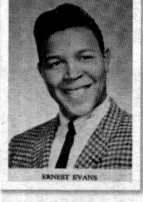

ERNEST EVANS

CHUBBY WAS just Ernest Evans to his classmates (above). BELOW: Anthony with Charlie Gracie (left), another famous South Philly grad.

"Labeled the "School of the Stars," South Philadelphia High School boasted such celebrities as Marian Anderson, Eddie Fisher, Frankie Avalon and Fabian. I'm pretty sure I'm the only graduate who can't sing, dance or act! But as the editor in chief of our school newspaper, I interviewed some of these talented teens, including my classmate Chubby Checker.

To us, he was Ernest Evans. I became friends with Ernie after he performed at an annual school talent show called Stunt Nite in 1957. He entertained the crowd with several numbers, including a spectacular rendition of "Bony Moronie." By the time he left the stage, the student body was chanting, "Ernie! Ernie! Ernie!"

and begging for an encore song.

Backstage I congratulated Ernie on his performance and interviewed him for an article in the school paper. A sophomore at the time, Ernie was thrilled to get the attention. About a year later, he went on to wow national audiences and achieve worldwide recognition as Chubby Checker.

Despite his fame, Ernie was always a South Philly kid who never forgot his neighborhood and friends. Before he became famous, my brothers and I often stopped to see Ernie on Saturday mornings at the Italian market where he worked in a poultry store. His big smile and cheerful greetings are fond memories from my teenage years.

Ernie married a former Miss World in 1964 and moved into a nice home in Philadelphia's

Chestnut Hill neighborhood. On my way home from work one day, I ran into him on the subway, where he was sitting alone, unnoticed by fellow passengers. I sat beside him and we slipped into conversation as though we were still friends and high school classmates and nothing had changed.

Whenever I enter a store or restaurant and hear "The Twist" or another of Chubby's records, Ernie's voice brings back so many wonderful memories of growing up in South Philly, enjoying the people and music that made our corner of the city so special.

ANTHONY J. EVANGELISTO
PENNINGTON, NJ

Pictured here is an article from *Reminisce* magazine that conveys a sense of the beginnings of this 1960 graduate's spectacular career.

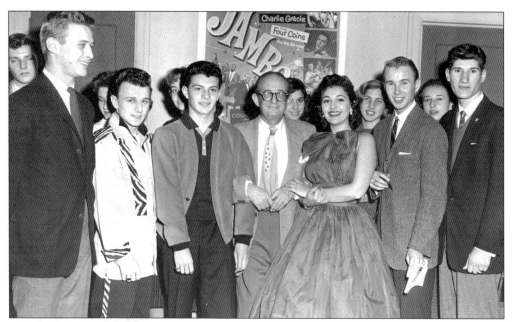

Southern has produced many teen idols. Two of them, Frankie Avalon and Fabian, launched their careers while still in school but still managed to graduate. The photograph above was printed in the *Philadelphia Sunday News* on November 24, 1957, to celebrate the premier of the film *Jamboree* starring three Southern graduates. From left to right are actor Paul Carr, Charlie Gracie (1954), Frankie Avalon (1957), Stanton Theater manager Al Plough, Jodie Sands (1950), actor Andy Martin, and Tony Evangelisto, editor of the *Southron*. In 1959, Frankie Avalon recorded "Venus," which stayed at number one for weeks. He made 13 hit records and appeared in 35 films; he is best known for the Beach Blanket movies with Annette Funicello. Below, Fabian (1960) is shown with principal Joseph Rossi as his graduation is assured. Fabian recorded numerous singles and albums, including the hits "Turn Me Loose" and "Tiger." As a film star, he has over 30 movies to his credit.

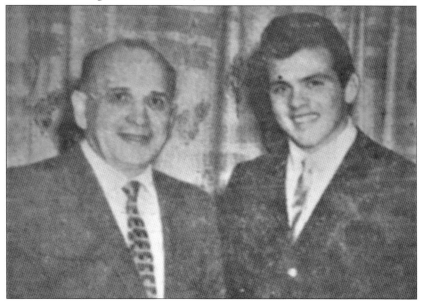

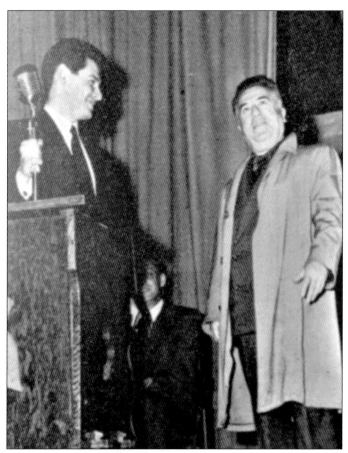

Sometimes Eddie Fisher was referred to as the Jewish Frank Sinatra; there was a period in the early 1950s when he was selling many more records than Sinatra. From 1951 through 1953, Fisher had three number-one hits. At age 18, he toured with Buddy Morrow and Charlie Ventura, then signed with RCA Victor Records. Fisher has two stars on the Hollywood Walk of Fame, one for recording and one for work in television. He had 35 singles reach the top 40. At left, he is seen in Southern's auditorium with legendary music teacher Jay Speck, who helped launch many singers and musicians, both popular and classical. Fisher is shown below performing for students in Southern's auditorium.

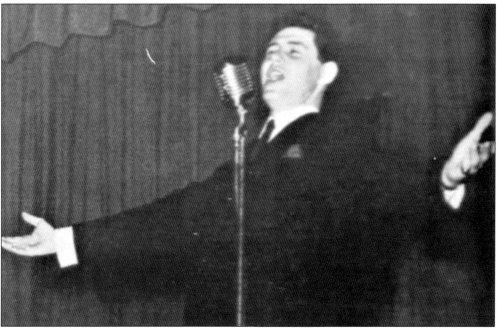

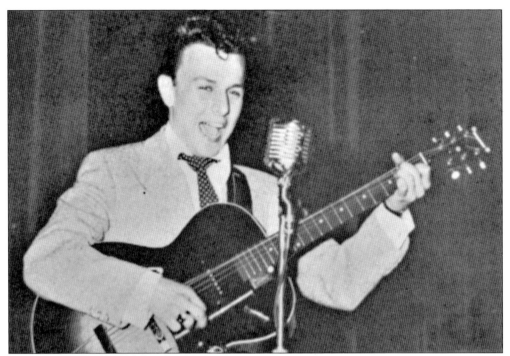

Shown above is Charlie Gracie (1954) on stage at Southern. Below, Gracie is enjoying memories with fellow Southernites after one of his local performances. From left to right are Tony Evangelisto, Gene Alessandrini, Gracie, and Bob Cerulli. Gracie wowed assembly audiences at Southern and at Furness Junior High School in South Philadelphia. In 1956, he joined Philadelphia-based Cameo-Parkway Records, and his career exploded with the 1957 release of "Butterfly." It sold three million copies. Gracie has been elected to the Rockabilly Hall of Fame and the Broadcast Pioneers of Philadelphia Hall of Fame.

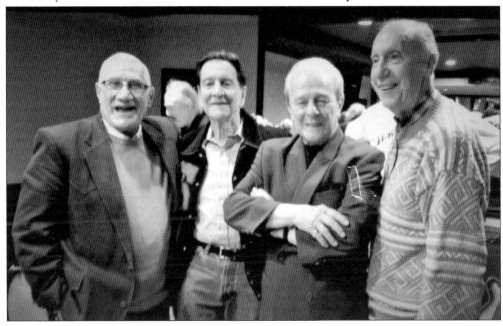

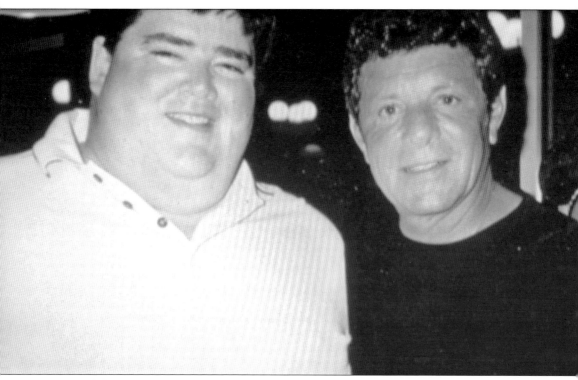

Pictured here are Frank Tenaglia (left) and Frankie Avalon. Gene Alessandrini called Tenaglia (1982) a lesser-known hero of Southern High: "He and his voice are, however, world class. I had the pleasure of knowing Frank when he was a student at Southern in the early 1980s. I watched his superb performances on stage in the school's auditorium. Years later, after Frank trained in classical voice at The Philadelphia College of Performing Arts and at Temple University, he sang at the Philly Pops with Peter Nero. He also toured with Nero and The Florida Philharmonic. Nero said that Frank 'has a pure and natural tenor voice, along with a rare warmth and solid musicianship. He combines these attributes to become that unique performer whose artistry results in instant communication to his audience as evidenced by consistent standing ovations.' "

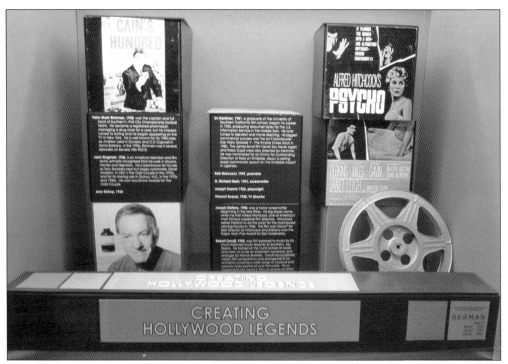

The photograph above shows a display case opposite the main office at Southern, highlighting some of Southern's stars of movies and television. Included are Peter Mark Richman (upper left) who began a Hollywood career with roles in *Friendly Persuasion* and other movies and on television in *Cain's Hundred*. Just below is a photograph of Jack Klugman in his role as Quincy in the television series *Quincy, M.E.*, for which he earned four Emmy Award nominations and three Emmy Awards (in 1964, 1971, and 1973), as well as a Golden Globe in 1974. He was also much-beloved in his role in *The Odd Couple*, for which he won an Emmy. At right is an archive photograph of Klugman. On the right side of the display is a replica of a poster for Alfred Hitchcock's *Psycho*, with a screenplay written by Joseph Stefano. One famous movie and television personality from Southern, Joey Bishop, was not included in this display but should have been. As a member of the Rat Pack, Bishop (Joseph Abraham Gottlieb) appeared in *Ocean's Eleven* and 13 other films, and starred on his own TV show, *The Joey Bishop Show*.

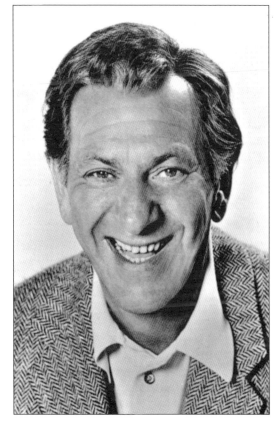

37

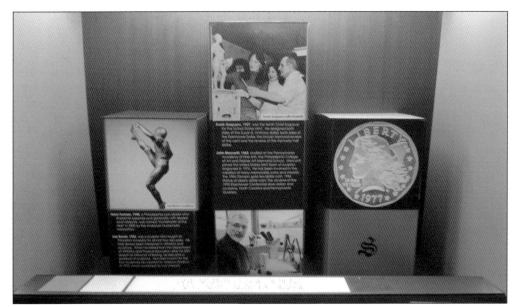

Shown above is another display near the main office focusing on Southern graduates who excelled in the arts, most notably Frank Gasparro, chief engraver of the US Mint, and Joe Brown, renowned sculptor. Brown's larger-than-life sculptures are found in abundance in Philadelphia and elsewhere. He is shown below, second from left, shaking hands with Phillies owner Bill Giles in front of two of his statues at Veterans Stadium, . He graduated from Southern in 1926, winning a football scholarship to Temple University. Brown left Temple and boxed professionally before studying sculpture at the University of Pennsylvania. He became the boxing coach at Princeton University and then began teaching sculpture there in 1939. He became a resident artist at the university and was made a full professor of art in 1962. He continued teaching at Princeton until his 1977 retirement, having created over 400 works, including statuettes, busts, and sculptures. Frank Gasparro attended the Pennsylvania Academy of Fine Arts after graduating from Southern in 1927. He developed his craft in Europe and was hired by the US Mint in 1942.

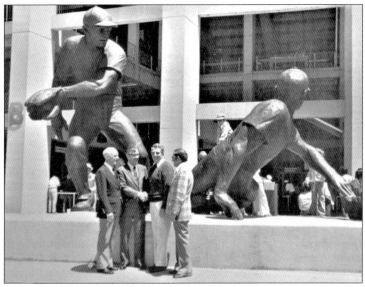

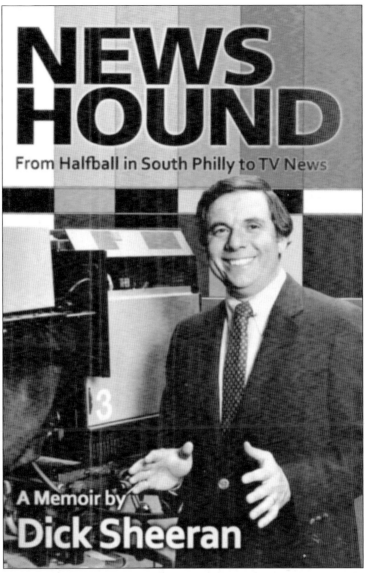

NEWS HOUND

From Halfball in South Philly to TV News

A Memoir by **Dick Sheeran**

Television, journalism, and radio have also been enriched by Southern graduates. Shown here is Dick Sheeran, former editor-in-chief of the *Southron*, who epitomizes the kind of success story that this book presents: a kid from South Philly who grows from humble beginnings to become an icon in the city, the region, and beyond. The Broadcast Pioneers of Philadelphia inducted Sheeran into its hall of fame in 2010, saying, "Dick Sheeran is a kid from South Philadelphia who never forgot his roots. The old neighborhood values filled every story he ever did in his 30 years as a reporter and sometime anchor for KYW-TV3. Dick's stories always revolved around people, most of them colorful, funny and full of soul, just like the people he grew up with in Hicks Street. Sheeran covered every type of story: from the nuclear accident at Three Mile Island to the Mummers Parade and countless other subjects in between. He went to Rome for the canonization of Bishop John Neumann, to Monaco for the funeral of Princess Grace Kelly, with other trips to political conventions in Kansas City, Atlanta and New York and the White House for a sit down with President Jimmy Carter."

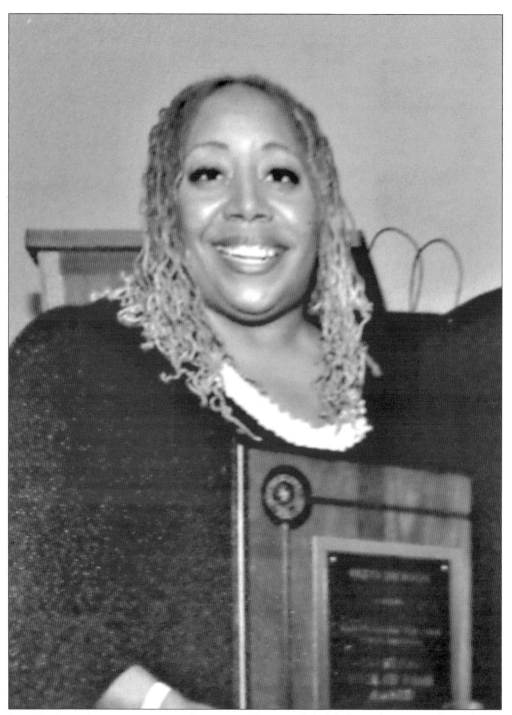

Patty Jackson is a prominent radio personality in Philadelphia who was inducted into Southern's Cultural Hall of Fame and has won many awards, including communicator of the year and Billboard/Airplay's local personality of the year. She has penned a weekly column for the *Philadelphia Tribune* for over 10 years and is the official voice of welcome and information at the Philadelphia International Airport.

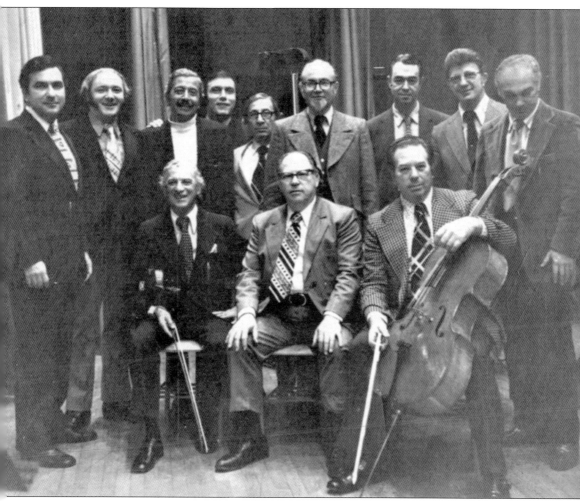

Numerous Southern graduates achieved fame in music. Pictured here are Southernites who played for the world-renowned Philadelphia Orchestra at the same time. From left to right are (seated) Dave Madison, Samuel Gorodetzer, and Harry Gorodetzer; (standing) Donald Montanaro, Joseph Lanza, Frank Costanzo, Louis Lanza, Armand DiCamillo, William Smith, Louis Rosenblatt, Ben Farnese, and Leonard Bogdanoff. Gene Alessandrini, chair of Southern's Cultural Hall of Fame Committee, says, "There are thousands of outstanding high schools in the United States which can boast of prominent graduates in several fields. Music is among the many areas in which Southern High has excelled. So many notable and outstanding musicians have walked the halls of the School of the Stars at Broad Street and Snyder Avenue in South Philadelphia since the early twentieth century. One can ask how in 1964 alone 13 members of the world-famous Philadelphia Orchestra were graduates of Southern High. Sociologists could probably explain why so many excellent musicians grew up in South Philadelphia and attended Southern High. Perhaps it was the culture of the immigrant populations of various ethnicities. Maybe it was the influence of outstanding teachers like the extraordinary Jay Speck, who was universally admired by scores of musicians . . . or was it the water?

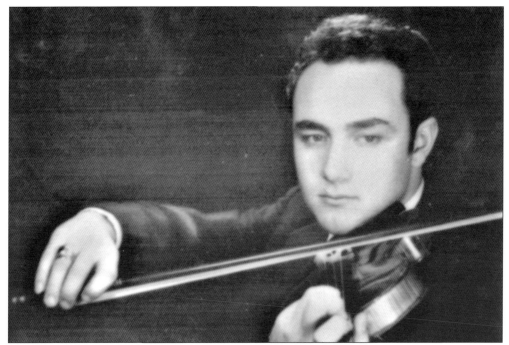

Louis "Lou" Lanza and his brother Joseph "Joe" Lanza (above) were both violinists with the Philadelphia Orchestra. Lou attended the Juilliard School of Music, enlisted and served in the US Army Band and played in the first violin section of the National Symphony Orchestra in Washington, DC. In 1964, Lou joined Joe in the violin section of the Philadelphia Orchestra and played for 47 years; he also played with the Philly Pops and was principal second violin of the Reading Symphony, the Trenton Symphony, and the Amerita Chamber Orchestra. Joe attended Juilliard, spent four years with the US Navy Band, and joined the Philadelphia Orchestra in 1958. He performed as violinist for 49 years in the Philadelphia Orchestra and for more than 25 years with the Philly Pops, and was a faculty member of the University of the Arts at Temple University. From left to right below are Louis Lanza, Dr. Richard DiAdamo, and Gene Alessandrini at the Alumni Association Hall of Fame Banquet in 2017.

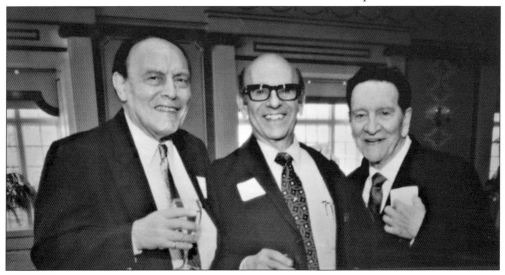

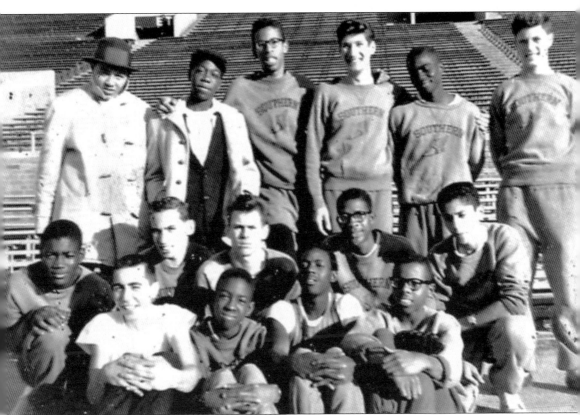

Charles Earland (standing far left) is pictured with Southern's cross-country team. Earland went on to achieve fame as a saxophonist. He was called "the Mighty Burner" because of his hard, simmering grooves. He recorded "*Cookin' with the Mighty Burner*," which reached number one on the Gavin Chart for national radio airplay. At Southern, he played baritone sax in a band that also featured Pat Martino on guitar, Lew Tabackin on tenor sax, and Frankie Avalon on trumpet. After playing in the Temple University Band, Earland formed his own group in 1960 and made his own recordings with Prestige. He passed away in 1999 after a performance in Kansas City, Missouri. A personal note from team captain Tony Evangelisto (standing third from right) at the time read, "Charlie was a member of our cross-country team and was loved by all of us. His smile and wonderful sense of humor brightened up our long hours of distance running. He was not in uniform when this photo was taken because he had injured a leg and was on crutches at the time . . . but his loyalty to the team was such that he attended our practices to cheer us on until he was able to run again."

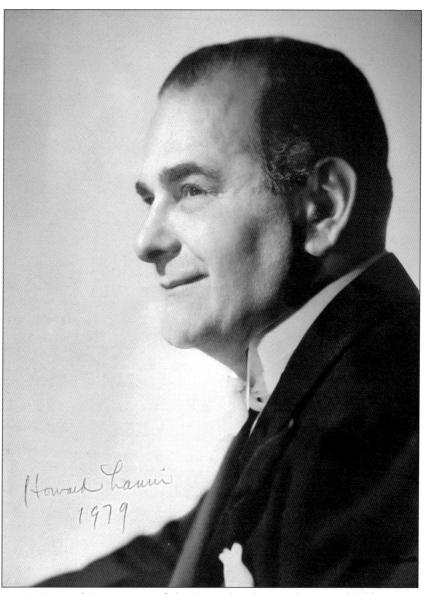

Howard Lanin
1979

Seen here is Howard Lanin, one of the Lanin brothers, who were highly popular and successful bandleaders. After arriving in the United States as Jewish immigrants from Russia, Benjamin and Mary Lanin raised their 10 children in South Philadelphia. Ben had a very popular band. He said the music was "Polish one night, Irish the next, then German, Jewish, Italian. A bar mitzvah, a wake, a wedding—whatever the public wanted, the public got." Some of the children attended Southern and played in the Southern High band. Nathanial "Lester" Lanin began with Southern's band and progressed to the great ballrooms of the Ritz-Carlton in Manhattan, the Bellevue Stratford in Philadelphia, and the Breakers in Palm Beach. He left Southern at the age of 15 to play music with his brothers and became an American jazz and pop bandleader. Sam Lanin studied the clarinet and violin; when he was 21, he joined Victor Herbert's Orchestra. Howard Lanin started out playing cornet with the South Philadelphia High School Band and left school at age 15 to pursue his musical dreams. Jimmy Lanin provided more dance music in the Lanin tradition.

Richard DiAdamo, retired first violin with the Pittsburgh Symphony Orchestra, is typical of the many Southern graduates who became professional classical musicians, playing for numerous major orchestras throughout the United States. DiAdamo performed for the Rochester Philharmonic Orchestra, played first violin with the Pittsburgh Symphony for decades, was the first violin coach for the Three Rivers Young Peoples Orchestra and the Pittsburgh Youth Symphony Orchestra, and was adjunct professor of violin at Washington and Jefferson College.

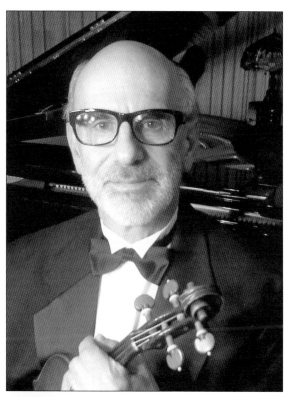

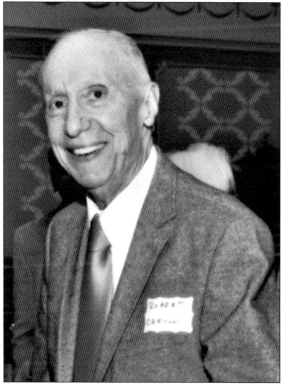

Robert Cerulli arranged music for numerous orchestras. He taught music at public schools in Cherry Hill, New Jersey, and at several colleges in the Philadelphia area. Cerulli graduated from the Curtis Institute of Music; he later received a degree in music from the University of the Arts and a degree in conducting from the College of New Jersey. He played for the Buffalo Philharmonic Orchestra and Greater Trenton Symphony Orchestra and was principal bass at the Greater Trenton Symphony and Delaware Valley Philharmonic Orchestras. He taught music in public schools for 29 years and is presently an adjunct professor of music at Burlington County College.

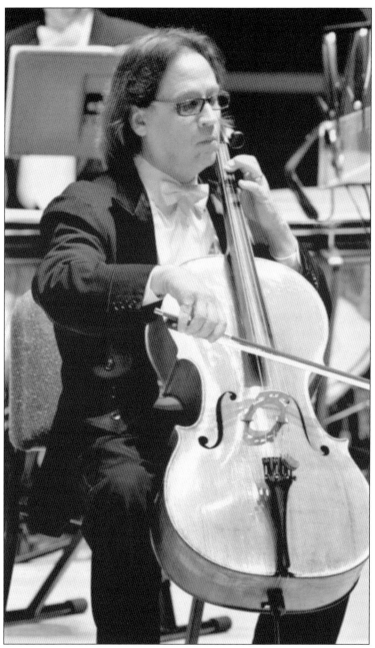

Anthony Pirollo is a highly accomplished cello player, composer, conductor, and president of the Atlantic City Musicians' Union. He played in Southern's orchestra, studied cello with William de Pasquale at the Philadelphia Music Academy, was guest principal cellist for Jose Carerras with the Houston Grand Opera, and played principal cello for Luciano Pavarotti, Placido Domingo, Joshua Bell, Frank Sinatra, Tony Bennett, Johnny Mathis, Sammy Davis Jr., and Jimmy Page and Robert Plant of Led Zeppelin. His first job as a professional musician was as a cellist accompanying Frank Sinatra at the Latin Casino. He has written compositions for many groups in the Philadelphia region and is principal cellist for the Ocean City Pops Orchestra; he also teaches at the Conservatory of Music Arts.

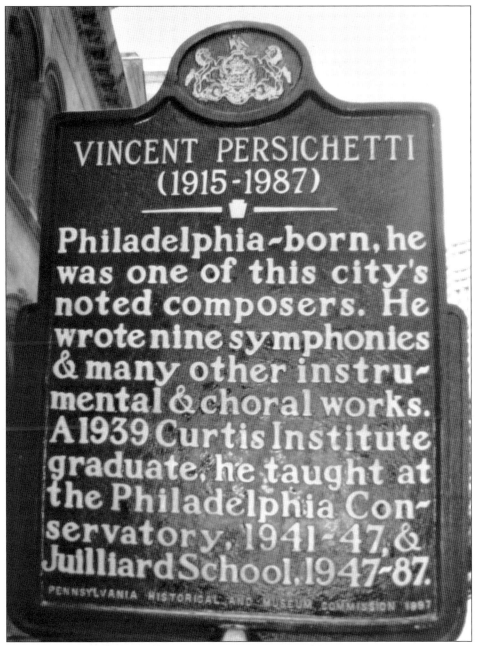

VINCENT PERSICHETTI
(1915-1987)

Philadelphia-born, he was one of this city's noted composers. He wrote nine symphonies & many other instrumental & choral works. A 1939 Curtis Institute graduate, he taught at the Philadelphia Conservatory, 1941-47, & Juilliard School, 1947-87.

PENNSYLVANIA HISTORICAL AND MUSEUM COMMISSION 1997

Vincent Ludwig Persichetti played piano and organ before the age of five. While at Southern, he won the National Federation of Music Clubs' first prize for original composition and played principal double bass in the All Philadelphia High School Orchestra. After receiving his diploma in conducting at Curtis Institute of Music, he earned his master's and doctorate music degrees at the Philadelphia Conservatory of Music. Persichetti was a virtuoso pianist and author, and wrote what is considered the classic text in music theory, *Twentieth Century Harmony: Creative Aspects and Practice*. He trained many noted composers in composition at Juilliard. He is considered to be one of the leading American composers of the 20th century. Pictured is his state historical marker.

Charlie Ventura (Charles Venuto) achieved recognition as a saxophonist. Michael Vitez, *Philadelphia Inquirer* writer, wrote, "When he was playing at . . . the Downbeat Club in Center City Philadelphia, Gene Krupa's manager was in the audience. Charlie soon got a call . . . to join Gene Krupa's band." He played with Stan Kenton, Charlie Parker, Lester Young, Count Basie, Jackie Gleason, and Frank Sinatra. In 1945, Ventura won the *Downbeat* magazine readers' poll in the tenor saxophone division. In 1946, he topped an *Esquire* poll; in 1948, he won a *Downbeat* poll for best combo. In 1949, he took the top spot in a *Metronome* poll for best small band. Pictured is Ventura's plaque on the Philadelphia Music Alliance's Walk of Fame on Avenue of the Arts.

Alfonso Cavaliere (1948) was a highly respected and successful musical director, conductor, and musician on Broadway. His shows included *Zorba the Greek* with Anthony Quinn, *Hello Dolly* with Pearl Bailey and Cab Calloway, *Fiddler on the Roof* with Zero Mostel, *West Side Story*, and others. He was concertmaster for the Philadelphia Lyric Opera Company and conductor for the Philadelphia Civic Ballet. The Alfonso Cavaliere memorial concerts and scholarship awards were started by his sister, Giovanna Cavaliere (who served for years as an assistant to Luciano Pavarotti), to benefit gifted musical students.

Three

Southern's Stars in Law and Service

How can the full value of one's education ever be measured? So many people make significant contributions to the world without glittering credentials. Perhaps the most significant credentials are dedication and service to others. Southern has played a prominent role in preparing students to serve their community and the world as political figures, lawyers, and judges and as contributors to the community in the military and in many other endeavors. As a former supervisor and chairman of the Board of Supervisors of Northampton, Bucks County, Pennsylvania, the author can attest personally to the incredible number of hours and extensive sacrifices involved in public service.

Many of our ancestors worked under oppressive conditions, often seven days a week, for bare subsistence wages. Especially in South Philadelphia, where so many are offspring of poor immigrants, it should never be forgotten what this was like. In the halls of South Philadelphia High School, a panel reads "Lest We Forget." This was intended to remind people to honor war heroes, but it also reminds them to honor the unsung heroes in our world: those who toil and struggle and, in their own way, maintain a world that nurtures everyone.

Historically, society did not provide the support, opportunities, or encouragement to women that they deserved. Hence, women are seriously underrepresented in the Southern annals. The greatest contributions of women, because of societal limitations, were through roles traditionally ascribed to them: wives, mothers, teachers, nurses, and secretaries. To their credit, women exerted influence in invisible and perhaps unappreciated ways. They are owed a profound debt for their dedication and service. Without them, the accomplishments chronicled on these pages would not have been possible.

Shown at top is the motto of the South Philadelphia High School for Girls: *Noblesse Oblige*. At bottom is the current motto of Southern with the emphasis on requirements for success: Wisdom, Industry, and Initiative. The girls' school motto expresses an ideal from the Middle Ages as part of the chivalric code. *Noblesse Oblige* identifies the responsibility of those in power to protect and defend those who are without power and are vulnerable. Persons who have experienced the trials and tribulations of immigration, poverty, and powerlessness are mindful of the need to help others to overcome the challenges in an urban environment. The boys' school motto presents what is required to succeed in life. These concepts are endemic to the culture of South Philadelphia High School. The history of Southern is a history of a school, the people who have been part of it, and the families, teachers, classmates, administrators, and neighborhoods that are so very much a part of the culture of South Philadelphia and Southern.

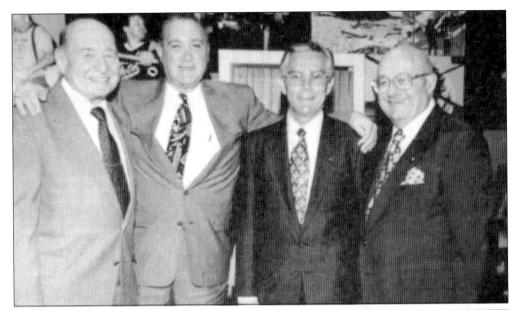

Southern has given Philadelphia many judges over the years. Pictured above are, from left to right, Judges Nicholas Cipriani (1935), Anthony J. DeFino (1946), Alfred DiBona (1953), and Charles Mirarchi (1941). At right is Judge Matthew Carrafiello (1964). Judge Cipriani was a veteran of World War II as a captain with the US Army. The Philadelphia City Council designated 1801 Vine Street as the Judge Nicholas Cipriani Family Court Building. Judge DeFino retired from Philadelphia's Common Pleas Court in 2007. Judge DiBono is remembered for his lifetime of dedication as a judge in the Court of Common Pleas in Philadelphia. Judge Mirarchi's career on the bench has done Southern great credit. Not pictured is Judge Harry E. Kalodner (1912), a federal judge on the US Court of Appeals for the Third Circuit. Kalodner was appointed by Pres. Harry S. Truman and served as chief judge from 1965 to 1966.

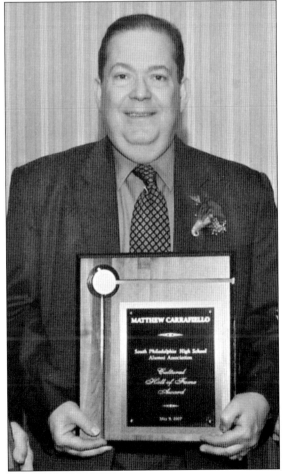

In the realm of public service, Dr. Israel Goldstein (1911) shines brightly. He graduated from the University of Pennsylvania at the age of 17 only three years after graduating from Southern. He was a founder of Brandeis University and helped to provide funds and support for the state of Israel. He helped found the National Conference of Christians and Jews. On his 80th birthday, Israeli prime minister Yitzhak Rabin and other prominent officials gathered at his home to pay him tribute.

Justice Russell Nigro (1964) earned a bachelor's degree from Temple University and graduated from the Rutgers University School of Law. In 1957, after 14 years in private practice, Nigro was appointed to Philadelphia's Court of Common Pleas by Gov. Robert Casey. In 1988, he was elected to a full 10-year term.

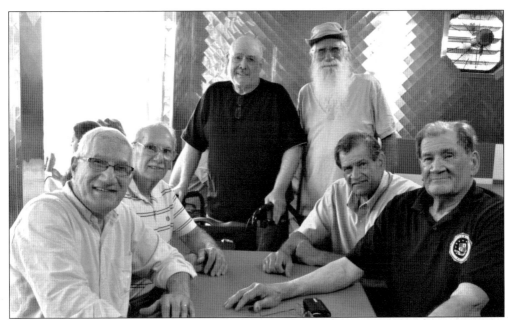

Tony Luke (short for Lucidonio), seen at right, attended Southern in the mid-1950s but left school to begin building his franchises. He has served the public exceptionally well; his franchises have substantial visibility in this region and well beyond the boundaries of the Delaware Valley. Tony Luke's restaurants/sandwich shops abound in the Philadelphia region, notably at Citizen's Bank Park, the Oregon Avenue location, Atlantic City, and the Wildwoods. Tony Luke's frozen line, Tony Luke's Pronto, is available nationally. He and his restaurants have earned numerous awards and recognition from both local and national publications. Tony Luke opened a location in Bahrain in 2010 and plans 60 more in the Middle East and North Africa. Above, Tony Luke is shown with his Evangelisto cousins. From left to right are (seated) Tony (1958), Frank (1961), Jim (1964), and Gil (1957); (standing) Luke and Biagio (1954).

Thomas "Tom" McCurdy (1958) served his community as a researcher for the Environmental Protection Agency. He attended Pennsylvania State University and earned a bachelor's degree in architecture, served as electronic technician with the US Air Force, later earning a master's degree in regional planning at Penn State. McCurdy was the chief environmental planner for the Joint Planning Commission of Lehigh-Northampton Counties, North Carolina. He became environmental planner for the EPA, now serving as research physical scientist there.

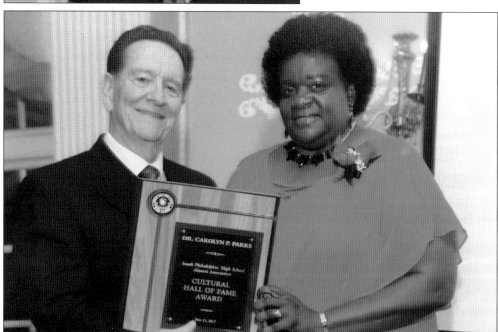

Dr. Carolyn Parks (1972) earned a bachelor's in biology from Wheaton College, a master's in community health education from Western Illinois University, and a PhD in health education from the University of Tennessee at Knoxville. For over 20 years, Dr. Parks held university level teaching positions in health education and public health. Here, Gene Alessandrini inducts Dr. Parks into the SPHS Hall of Fame.

One of Southern's most widely recognized former students is Frank Rizzo (right), whose career in the City of Philadelphia Police Department, as a two-term mayor of the city, and as a talk-show host has had a profound impact on Philadelphia. His strong leadership in the police department and at city hall has won him many supporters. He attended Southern from 1936 to 1938. His selection as police commissioner and election to the office of the mayor twice shows his popularity. Perhaps the most compelling evidence of the kind of admiration and devotion that Rizzo achieved is found in the words of one of the police officers who served under him in the police department. Cpl. Gil Evangelisto shares that, "In August of 1963, there was an altercation in a business establishment, a crowd gathered and a riot ensued. The next day, during rioting, looting, and breaking in and setting fires amidst total chaos, Frank L. Rizzo was sent to quell the unruly crowds. Rizzo's tough cop approach and command decisions made me proud." Pictured below are Rizzo (left) and police corporal Gil Evangelisto.

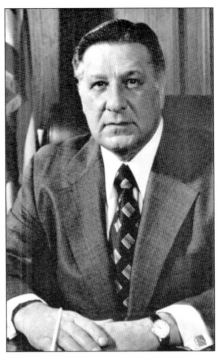

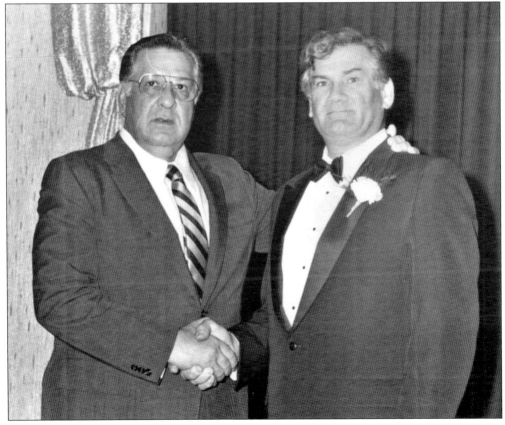

At left is Dr. Kenneth Stein, who graduated first in his class in 1961 at Southern and won a four-year scholarship to Temple University, graduating summa cum laude and receiving a full scholarship to Temple Medical School. He completed a residency in dermatology at the University of Pennsylvania. Dr. Stein served with the US Army as assistant chief of dermatology; he engaged in private practice as a board-certified dermatologist and dermatopathologist. Dr. Stein married high school sweetheart Sandy Austin Stein (1963), pictured below. She shares, "My legal name is Sondra, but I always go by 'Sandy.' When I paint, I use the name 'Sandy Austin Stein.' My parents had Austin's Card and Gift Shop on Seventh Street for 40 years. In 1977, after moving to northern California, I decided to take art classes." Sandra won best of show in 1979 for her sculpture entitled *Roots*. In 1981, she won best of show for her painting *Thank Heaven for Little Girls*. Her original artwork was used in 1995 in an HBO film produced by Robert Redford, *Grand Avenue*, about Native Americans living in Santa Rosa, California.

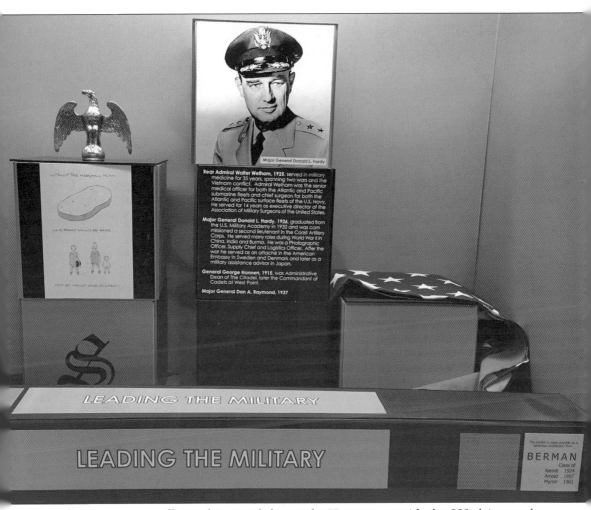

Major General Donald L. Hardy

Rear Admiral Walter Welham, 1925, served in military medicine for 35 years, spanning two wars and the Vietnam conflict. Admiral Welham was the senior medical officer for both the Atlantic and Pacific submarine fleets and chief surgeon for both the Atlantic and Pacific surface fleets of the U.S. Navy. He served for 14 years as executive director of the Association of Military Surgeons of the United States.

Major General Donald L. Hardy, 1926, graduated from the U.S. Military Academy in 1932 and was commissioned a second lieutenant in the Coast Artillery Corps. He served many roles during World War II in China, India and Burma. He was a Photographic Officer, Supply Chief and Logistics Officer. After the war he served as an attaché in the American Embassy in Sweden and Denmark and later as a military assistance advisor in Japan.

General George Honnen, 1915, was Administrative Dean of The Citadel, later the Commandant of Cadets at West Point.

Major General Dan A. Raymond, 1937

LEADING THE MILITARY

LEADING THE MILITARY

BERMAN
Class of
Kermit 1924
Arnold 1957
Myron 1961

As a former US Army officer who served during the Vietnam era with the 223rd Armored Cavalry, the author is touched by the heroics and the involvement of Southern's graduates throughout the nation's history. This photograph shows a display case that honors Southern's military heroes. Southern has produced six generals and six admirals, an original Tuskegee airman, and a legion of soldiers, sailors, and airmen of different ranks. From the lowest ranks to the highest, military service deserves our praise and gratitude, because everyone in uniform and their families have contributed to the freedom enjoyed today. The names of the yearbooks during the war years—*Ramparts*, *Horizons*, and *Crossroads*—manifest the reality of the times, with support for and kinship with those in uniform. The number of former Southern students who have served the country, the number injured in battle, the number who suffered severe psychological trauma from military action, and the number who made the ultimate sacrifice for the nation's freedom is beyond counting.

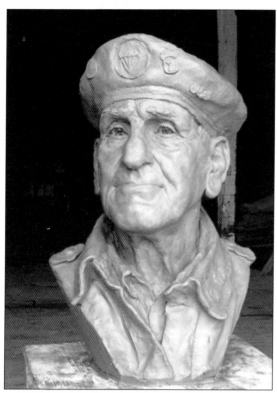

Many books and movies have been produced about the D-Day invasion of Normandy and the Battle of the Bulge. One of the most thoughtful and powerful portrayals was the HBO series *Band of Brothers*. This series is of interest to the South Philadelphia High School family because two members of the fabled 101st Airborne Division came out of Southern: William "Wild Bill" Guarnere and Edward "Babe" Heffron. Guarnere's bust is shown at left. Below, Heffron's statue stands beside a plaque detailing his military exploits in a memorial park near his old neighborhood in South Philadelphia on Second Street, just south of Washington Avenue. *Band of Brothers* captures the incredible bravery of these two sons of Southern High School in a powerful and dramatic way. (Left, courtesy of the Guarnere family.)

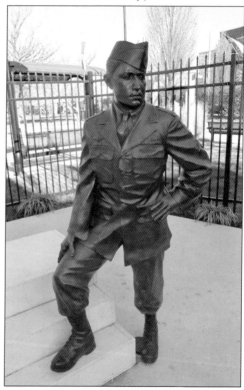

Daniel Raymond (1937) is seen when he attended the US Military Academy, graduating in 1942. During World War II, he commanded a platoon in the 10th Engineer Combat Battalion and became its deputy commander. He served with the amphibious force of the Atlantic Fleet and with the 8th Amphibious Force in the Mediterranean, seeing action in North Africa, Sicily, Salerno, and southern France. Following World War II, he served on the staff and faculty of the Infantry School and the Command and General Staff College. He earned a master's degree in civil engineering from Harvard University.

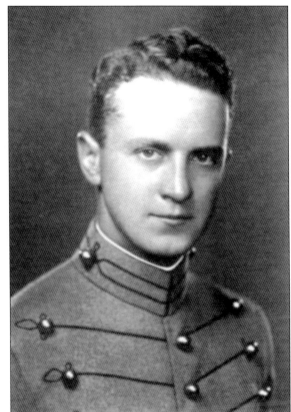

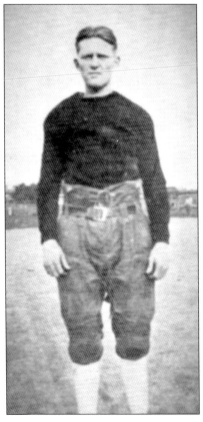

Upon graduating from Southern in 1925, Walter Welham turned down an offer to play professional baseball to enter the medical profession and, later, the US Navy. Welham's service was truly remarkable. Rear Adm. Walter Welham served for 35 years in military medicine including service in two wars and in Vietnam. He was senior medical officer for both the Atlantic and Pacific submarine fleets and chief surgeon for both the Atlantic and Pacific surface fleets of the US Navy.

Above, Tony Fasolo (1955) is seen with Madeline Albright (right) as a volunteer for the Vietnam Veterans Memorial Fund. Fasolo went to Temple and earned a degree in elementary education and was commissioned as a second lieutenant through Temple's Army ROTC program. Fasolo served in personnel and administration work with the Army, with a tour in Korea and a year in Vietnam as the casualty reporting officer. Lt. Col. Fasolo was later assigned to the Pentagon. Southern is proud to have an original Tuskegee Airman as a graduate. Lt. Col. George E. Hardy (1942) is shown below at left with his sister Frances and former Alumni Association president Sam Chatis. Hardy joined the Army Air Corps and trained at Tuskegee Army Air Field. He flew 21 missions in World War II and six combat missions over Korea. After Korea, he was attached to the 18th Special Operations Squadron in Vietnam. Hardy flew 70 sorties, attacking enemy supply traffic through northern Laos and along the Ho Chi Minh Trail. He was decorated with the Distinguished Flying Cross with Valor, the Air Medal with 11 oak leaf clusters, and the Commendation Medal with one oak leaf cluster.

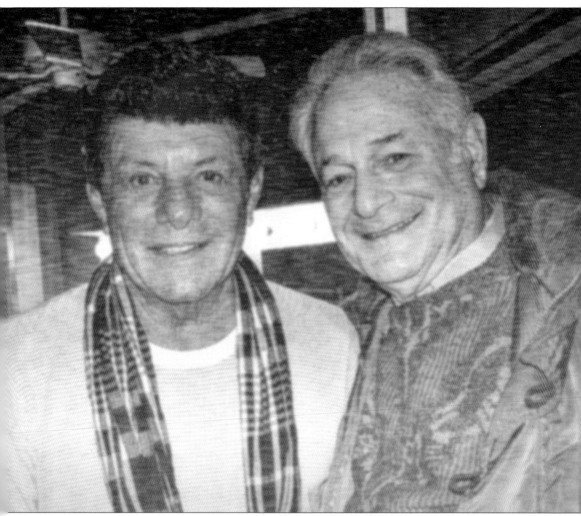

Dr. Harvey Yorker (1958), pictured at right with Frankie Avalon, graduated from Temple University with a bachelor's degree in biology and then the Philadelphia College of Osteopathic Medicine, earning his doctor of osteopathic medicine degree. He was chief of urology at Parkview Hospital in Philadelphia and chair of its Urology Residency program. Yorker spent more than 20 years in the Air National Guard and retired as a lieutenant colonel, receiving many awards, including a Meritorious Service Medal with oak leaf cluster and an Air Force Commendation award with oak leaf cluster.

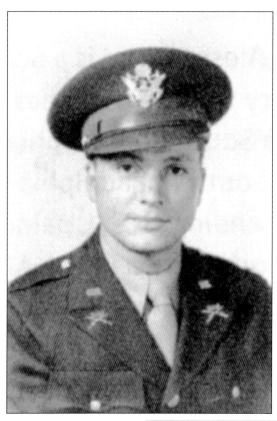

Ubaldo Alessandrini is a Southern graduate (1936) who served his country in an exemplary fashion during World War II. After graduating from Southern in 1936, he received a scholarship to study Italian and French at the University of Pennsylvania, graduating in 1940. On September 9, 1943, as a member of the 36th Infantry Division, he landed at Salerno as part of the invasion of mainland Italy; he served in Italy from 1943 until 1946. Alessandrini was a captain in military government in Italy, later retiring as a lieutenant colonel from the US Army Reserve. He came home to serve the children in South Philadelphia as a beloved teacher at Furness Junior High School and South Philadelphia High School.

At right is Sgt. Anthony DiGiovanni (1947) of the US Marine Corps, receiving his promotion from General Swinke on August 17, 1972. DiGiovanni has been awarded numerous medals for his exemplary service: Korea Service Medal with three clusters; United Nations Service Medal, National Defense Service Medal; Combat Action Ribbon; Presidential Unit Citation; Armed Forces Expeditionary Medal, Navy Unit Commendation; Vietnam Service Medal, and many others.

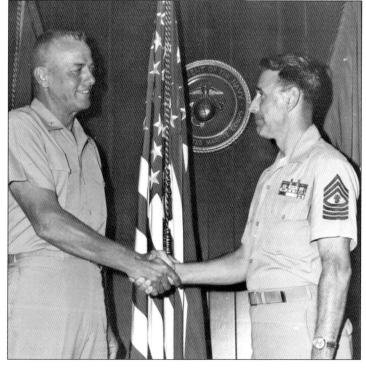

Military service has an impact on families across generations. Pictured above are, from left to right, (seated) Antonio, Josephine, and Liz Capelli; (standing) Rose, Steve, and Joan Capelli. Antonio and Josephine's son Pfc. James Capelli (uncle to the five Evangelisto brothers) was killed in action in France on September 15, 1944. In May 1943, James wrote home from Camp Hood, Texas: "Dear Mom, I am writing you a few lines to let you know that I am well and hope to hear the same from you. Today we got paid. I am sending it all home. I do not need it now. . . . So long, Jim." The picture below is a testimonial to the fact that normal life continues even during wartime. Sgt. Anthony Capelli, the groom, marries his bride, Rose, with his brother Steve, also in uniform, standing next to Rose. The ring bearer is Tony Evangelisto.

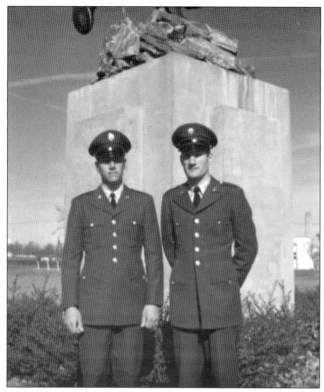

The nephews of the Capelli family served at a later time in our country's history. Pictured at left are Frank (left) and Tony Evangelisto, who completed infantry training at Fort Dix, New Jersey. They were on alert during the Cuban Missile Crisis, ready for immediate deployment to Cuba for combat. They remember being restricted to the regimental area, with rifles and duffle bags ready for a quick flight in the troop transport planes next door at McGuire Air Force Base. After graduating from Officer Candidate School, Second Lt. Tony Evangelisto (below) was stationed at Fort Knox, Kentucky, completing the Armor Officer Basic Course in preparation for deployment to Vietnam.

At right is airman James Evangelisto, US Air Force cryptographer in the Vietnam era. Below, airman Gilbert Evangelisto is shown with his wife, Barbara. He saw active duty during the Cuban Missile Crisis. Not pictured is Biagio Evangelisto, who was stationed at Walter Reed Army Hospital in Washington, DC, with the US Army as a hematologist.

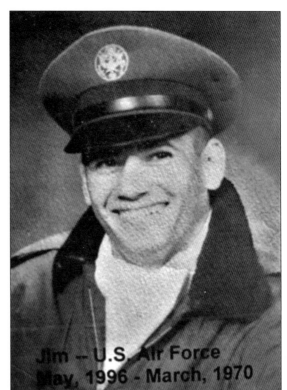

Jim — U.S. Air Force
May, 1996 - March, 1970

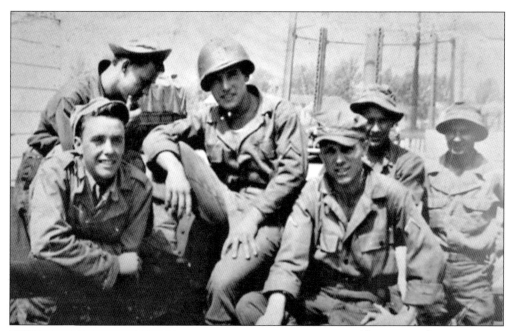

The stories that come down from generation to generation contain the pathos and sorrow that befalls everyone as a consequence of world events. Pictured above are James Capelli (center, wearing helmet) with his squad in action; he is shown at left in dress uniform. The current generation is faced with the challenges of terrorists and renegade regimes around the world who threaten our peace and security. Gratitude is owed to those who serve in uniform and to the families that support them. Southern is grateful to its former students for their sacrifices.

Four

SOUTHERN'S STAR ATHLETES

Memories of high school weave a tapestry of varied images, including experiences in the school building itself and outside of it at various school events, particularly sports of all kinds. Gifted athletes frequently move on to colleges or universities and professional ranks, but their exploits in high school contribute greatly to a sense of school spirit and pride.

One reality is that an urban high school such as South Philadelphia High School does not have access to the open space and natural amenities available to schools in rural locations. In South Philadelphia, there are very limited open spaces, so children learn to adapt by inventing games suitable for play on streets and street corners. "Half ball" (sometimes called "stick ball") is a game usually played on a small street where traffic is limited, with broomsticks for bats and a hollow rubber ball. Another street game was "buck-buck," whose intricacies would require several pages to describe and could only be explained by a South Philly native. The point is that urban children do not have access to the kinds of terrain and space that would enhance athletic performance. Hence, the exploits of Southern's athletes who have gone on to greater heights are truly remarkable because they did it without the benefits available elsewhere. This is a real tribute to the accomplishments of our athletes.

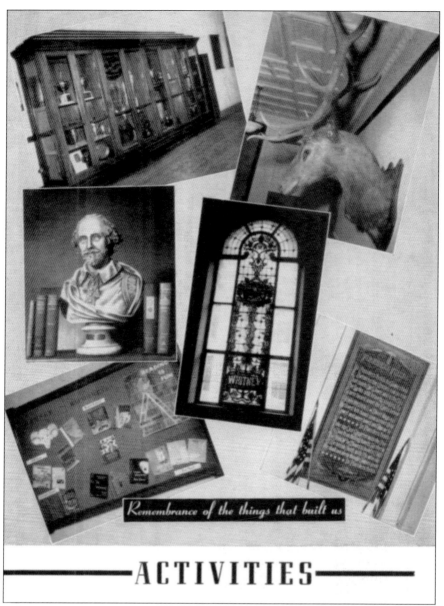

Remembrance of the things that built us

ACTIVITIES

Pictured are mementoes from the old South Philadelphia High School demolished in 1955. The trophy case is home to many of the city championship awards won by Southern's athletes. The elk head has special meaning to Southernites; this is Izzy the Elk who looked down upon students in John Bender's English classes on the second floor. Interestingly, Bender claimed to be related to Chief Bender, the fabled pitcher for the Philadelphia Athletics. Izzy's origins were never known to the students who stared into his eyes each day. The bust of Shakespeare was intended to inspire pupils to their poetic best, and the stained-glass panel and the plaque on the lower right are reminders of everyone's debt to the military. In the lower left is a bulletin board from the main hallway of the original building.

Early in Southern's history, outdoor facilities were limited. At right, star miler Biagio Evangelisto (1954) runs down the hallway on the third floor of the original school building, which was used as an indoor practice facility. The third floor was in the form of a rectangle, approximately one quarter of a mile in length. Below, Evangelisto practices outdoors at Southern's one-fifth-mile cinder track at Tenth and Bigler Streets. While training and performance conditions were spartan at best, Southern's athletic heritage still yielded some truly spectacular athletes and accomplishments, but sports are also significant because they provide valuable life lessons. One of the critically important features of an urban public high school is that it brings together a mixture of races, religions, and cultures/countries of origin and, in doing so, allows students to learn life's most significant lessons alongside others who share similar goals and aspirations.

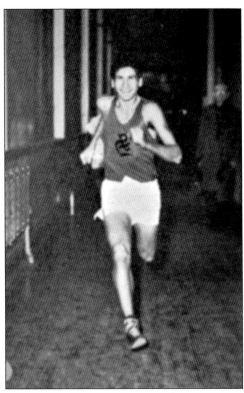

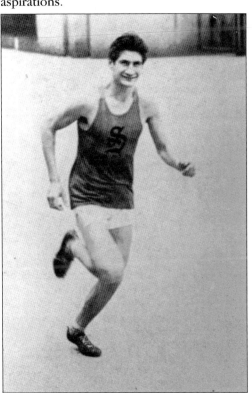

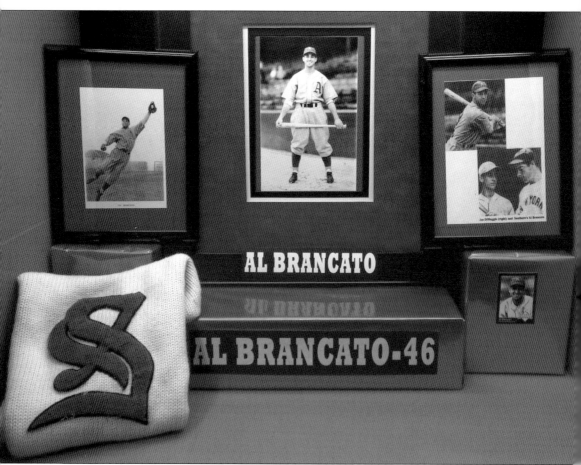

Al Brancato (1939) played third base and shortstop for the Philadelphia Athletics from 1939 to 1941 and then again in 1945 after serving during World War II. Brancato lettered in four sports at Southern (baseball, football, gymnastics, and basketball) and participated on four championship teams. He signed with the Athletics at age 18 and led the Eastern League in RBIs in 1939. After 1941, he served in the US Navy on the heavy cruiser USS *Boston*.

Dominic "Dom" DiCicco (1953) is a world-class bowler, holder of many records, and winner of two gold medals in Olympic competition. In 1968, DiCicco set two world records, one for eight games, and one for 16 games. The 16-games record still stands today, over 45 years later. In 1969, with the late Joe Ostroski, he set the Philadelphia doubles city record. The pinnacle of DiCicco's bowling career came in 1971 when he competed on the US team in the Federation Nationale D'Quillers, known as the World Bowling Olympics.

Angelo Dundee (Angelo Mirena) attended Southern in the late 1930s, and was a Hall of Fame professional boxing trainer who trained Muhammad Ali and Sugar Ray Leonard. Dundee received numerous awards throughout his career and was hired to train Russell Crowe for Crowe's role as James J. Braddock in *Cinderella Man* and appeared in the film as *Angel*, the corner man.

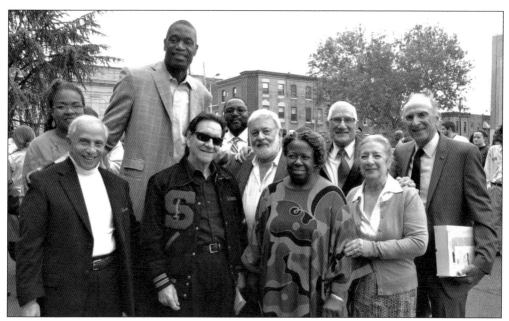

Eddie Gottlieb (1916) is an icon in Philadelphia and in professional basketball. He is the founder of the National Basketball Association, and was the coach, manager, and owner of the Philadelphia Warriors. Inducted into the Basketball Hall of Fame in 1971, he is known in basketball circles as "the Mogul." The Pennsylvania historical marker seen below was erected on May 21, 2014, in a ceremony attended by Dikembe Motumbo (eight-time NBA All-Star), Harvey Pollack (Philadelphia 76ers statistician), and Rich Westcott (author of *The Mogul: Eddie Gottlieb*). The picture above was taken at the dedication of the historical marker; from left to right are (first row) Ed Rocco, Gene Alessandrini, Henrietta Patrick, and Rita D'Armi; (second row) Karimah Speaks, Dikembe Motumbo, Willie Pollins, Marc Adelman, Tony Evangelisto, and Sam Chatis (former president of the alumni association).

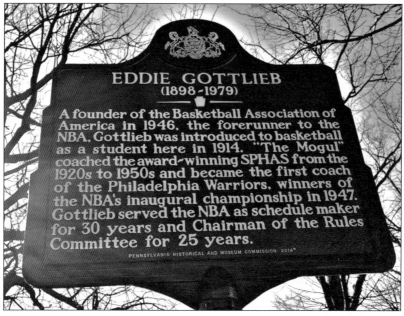

Pearl Perkins Nightengale (1932) won honors as the AAU Middle Atlantic and National Gymnastics champion in 1941 and 1943. She was selected to compete in the 1936 Olympics but was not able to because of Nazi anti-Semitism. Her biography by the US Gymnastics Hall of Fame reads, "Over a half century ago, South Philadelphia gymnast Pearl Perkins was considered the best American gymnast of her time. Her qualities as a performer have been compared to Mary Lou Retten, the first American to win the coveted Olympic gold medal in the AA. She has been called perhaps the most talented South Philadelphia athlete of all, and probably the least well known."

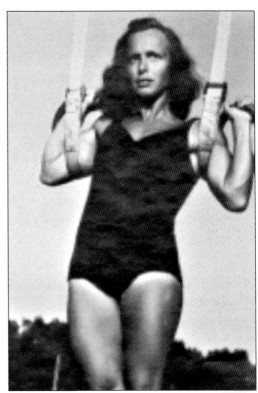

John Sandusky (1945) was a first-team All-American football player at Villanova and played professionally with the Cleveland Browns and Green Bay Packers. After his playing days, he coached for 36 years, for the Baltimore Colts, Philadelphia Eagles, and Miami Dolphins.

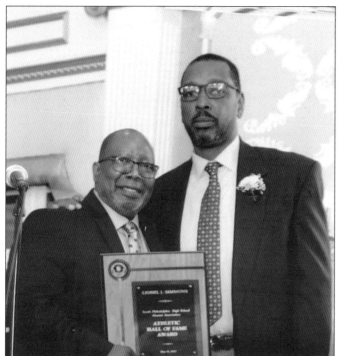

At left, Lionel Simmons (right) is inducted into Southern's Athletic Hall of Fame. Below, he stands with fellow LaSalle alumnus Tony Evangelisto. Simmons (1986) is a former professional basketball player with the Sacramento Kings and is the third leading scorer in NCAA Division I history. After graduating from Southern, Simmons went on to star at LaSalle University in Philadelphia. He was inducted into Philadelphia's Sports Hall of Fame in 2008. With the Kings, Simmons played for seven seasons. He won the John R. Wooden Award (1990) and was named to the NBA All-Rookie Team (1991).

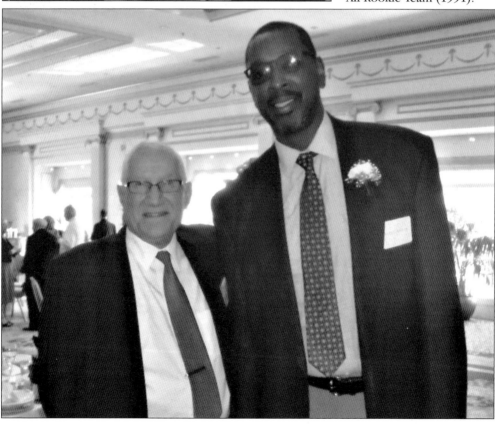

Mario Frank Todaro (1950) was horizontal bar champion of Philadelphia and captain of Southern's 1950 city title team. As a champion gymnast at Penn State, he was good enough to be offered tryouts for the Olympics in 1952 and 1956. He earned a master's degree in industrial arts education at Penn State and art education at Temple University's Tyler School of Art. Todaro taught industrial technology at Upper Darby High School and later became a Cheyney University professor.

Robert "Bob" Petrella (1962) could have been on his way to stardom in Hollywood, but his true calling was in the world of sports. He was the captain of the public league championship football team and played varsity basketball and baseball. Petrella went to the University of Tennessee. He played safety and defensive back for the Miami Dolphins and helped them win their first AFC championship and a trip to Super Bowl.

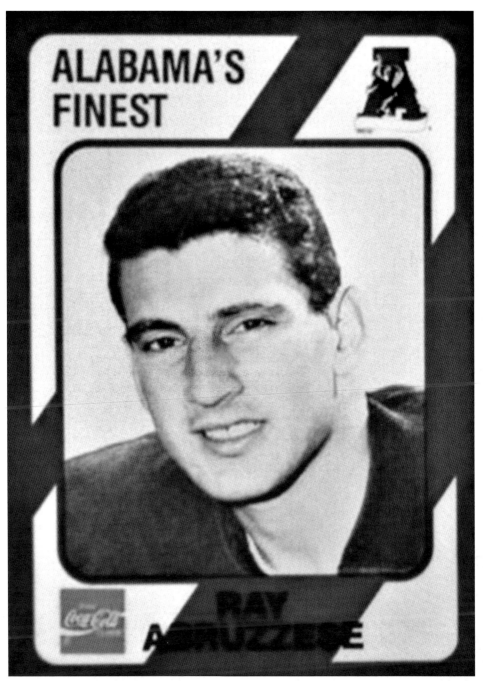

ALABAMA'S FINEST

RAY ABRUZZESE

Following his graduation from Southern, Ray Abruzzese went to the University of Alabama. He had a major impact on modern professional football. He roomed with Joe Namath when both were at Alabama. Namath told Jets owner Sonny Werblin that he would lean toward the Jets if they would acquire Abruzzese. Abruzzese played defensive back for the University of Alabama and then moved on to play for the Buffalo Bills from 1962 to 1964. In 1964, the Bills won the AFL championship by defeating the San Diego Chargers 20-7. Abruzzese was then traded to the Jets.

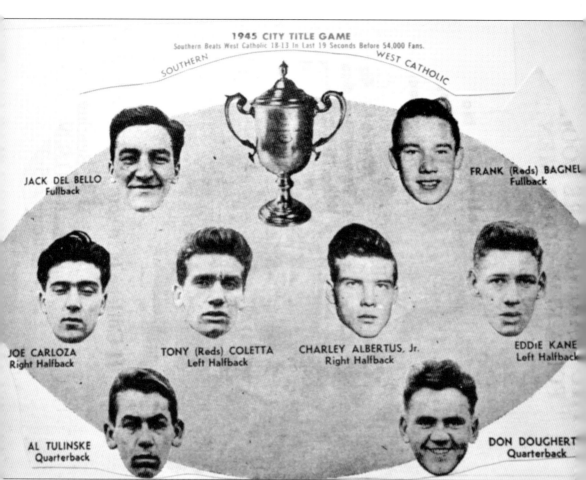

1945 CITY TITLE GAME
Southern Beats West Catholic 18-13 In Last 19 Seconds Before 54,000 Fans.

SOUTHERN

WEST CATHOLIC

JACK DEL BELLO
Fullback

FRANK (Reds) BAGNEL
Fullback

JOE CARLOZA
Right Halfback

TONY (Reds) COLETTA
Left Halfback

CHARLEY ALBERTUS, Jr.
Right Halfback

EDDIE KANE
Left Halfback

AL TULINSKE
Quarterback

DON DOUGHERT
Quarterback

Southern's 1945 championship team, pictured here, is considered one of the greatest high school football teams of all time. In what came to be known as "the Bobby Sox Bowl," Anthony "Reds" Coletta threw the game-winning pass to Al Tulinsky in the 19-13 win over West Catholic in a championship game witnessed by 54,000 spectators at Franklin Field. The game involved Southern scoring three times in the final 7:40 to erase a 13-0 deficit, and highlights were shown worldwide in movie theaters by Paramount. The backfield went on to great accomplishments after graduation. Coletta became a senior chemist for the DuPont company; Al Tulinsky became a professor of chemistry at Michigan State; Jack DelBello played for the Philadelphia Eagles and Baltimore Colts; Joseph Carlozo graduated from West Chester University and became a football coach.

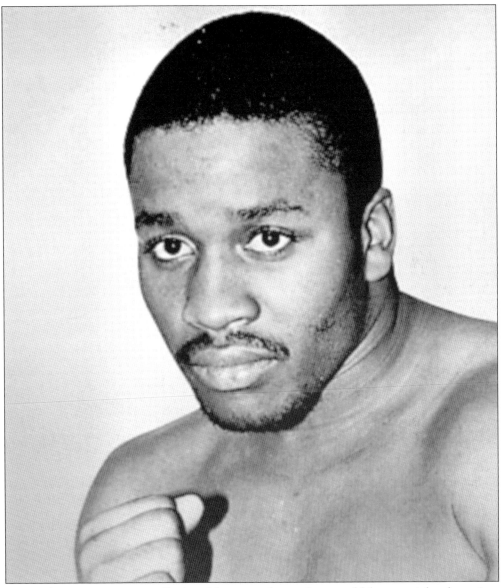

Tim Witherspoon was a professional boxer and two-time world heavyweight champion, having held the WBC title in 1984, and the WBA title in 1986. When he won his second title, Witherspoon joined Floyd Patterson and Muhammad Ali as the only boxers to win multiple world heavyweight championships. Witherspoon also worked as a regular sparring partner for Ali, who was trained by Southern's Angelo Dundee.

South Philadelphia High School Alumni Athletic Hall of Fame

RAY ABRUZZESE '56
KEN ADAMS '65
TONY ALFANO '33
EDDIE ALTIERI '46
BOB ARANGIO '56
BEN BARRETTA '48
PAUL BARTOLOMEO '33
DAVE BELOFF '24
HUGHIE BLACK '16
NATE BLACKWELL '83
FRANK BLATCHER '48
MILT BLITZ '33
LOU BORDO '39
FRED BOVOSO '54
JAKE BOYLE '54
AL BRANCATO '39
DR. JOE BRANCATO '32
EROY BROWN, JR. '70
JIMMY BROWN '31
STAN BROWN '47
MARK MOOKIE BUNINE '16
JOE BRIDDELL '63
FRED BUONAVOLTA '51
BEN BURDETSKY '46
GAETANO CAPUANO '46
NICK CARCHIDI '50
JOSEPH CARLOZO '46
PETE CARRIERI '50
TONY REDS COLETTA '47
MIKE CUDEMO '45
JOE D'AMILLIO '33
JIMMY DE GEORGE '49
JACK DEL BELLO '46
PAUL DELLAVECCHIA '62
DAVE DENENBERG '33
STEVEN DE PRINCE '75
BENNY DESSEN '21
JIMMIE DESSEN '25
DOMINIC DI CICCO '53
FRED DIODATI '50
TONY DI PIETRO '68
ANTHONY DI PRIMO '51
JOHN DI SAVERIO '50
TONY FABRIZIO '62
GARY FARNESI '79
RAY FARNESI '53
ROBERT FERGUSON '14
CHARLES FERRANTE '51
JOHN FERRINI '50
CARMEN FERULLO '60
TITO FIORVANTI '50
PETE FOLEY '23

FRANK FORBES '10
JOHN FRATTO '53
CHARLES FRIEBERG '30
RON FUNARO '68
JOHN M. GALLANTE '47
ERNIE GALLO '56
ERNIE GALLO '37
CARMEN GALONE '56
LABEL GOLDBLATT '25
MENCHY GOLDBLATT '24
BARRY GOLDSTEIN '51
EDDIE GOTTLIEB '16
BOB GREENBERG '55
MOISHE INGBER '14
WILLIE JACOBS '50
REDS JORDAN '40
STEVE JUENGER '14
SONNY KANE '50
REDS KLOTZ '40
WILLIAM P. KORAN '55
MILT KORMANICKI '45
IRV KOSLOFF '30
DAN KRAYNAK '53
MIKE KRAYNAK '40
SAM LAPOLLA '38
TONY LAPOLLA '45
JOHN LAPROCIDO '55
CARMEN LA ROCCA '51
JOHN LA ROSA '57
GEORGE LATERA '65
BILL LEOPOLD '19
EDDIE LERNER '44
ALAN LEVIN '58
HARRY LITWACK '25
MIKE LUBIN '16
RON MALANDRO '72
RALPH MANFREDI '49
JOSEPH MARGOLIS '54
HARRY MARNIE '37
EDDIE MATTIA '55
ROBERT MC CANN '47
TOM MC COLLAM '38
BRIAN MC FADDEN '54
LANCE MC FADDEN '56
AL MOCCIA '66
JIM MULDOON '54
JOE MURACCO '51
CARMEN MUSITANO '48
REGINALD NICHOLS '69
ROCCO PARISI '42
PEARL PERKINS NIGHTENGALE '32
BUFUS BUCKY OUTLAW '78

HERMAN CHICKIE PASSON '19
JOE PASTELLA '51
BILL PAULLIN '46
MIKE PIERNOCK '55
JOHN PENDINO '47
MIKE PENDINO '43
FRANK PETRELLA '41
FRANK PETRELLA, JR '64
ROBERT PETRELLA '62
JOE PETRONGOLO '48
JOHN PHILLIPS '47
CARMEN PICCONE '47
PHIL PITIS '46
PAT POTAMKIN '27
DOM RAIA '87
BILL RANKIN '62
ROBERT RAUCCI '57
PETER MARK RICHMAN '45
REDS ROSAN '30
PETEY ROSENBERG '37
SAM ROSENBERG '39
EDWARD ROSENWALD '28
HARRY ROSETSKY '17
TOM SABOL '45
JOHN SANDUSKY '45
LOU SBARRA '70
LOU SBARRA, JR '59
JOE SCARPA '65
FRANK SCHIAVO '60
GERALD SCOTT '70
REDS SHERR '22
LIONEL SIMMONS '86
FRANK SODANO '48
PETER SPURIO, JR '75
AL STANGO '50
ADAM W. SWIGLER '14
PETE TATE '58
THOMAS TERRY '99
MARIO TODARO '50
JIM TOLAND '38
GREG TORNATORE '48
PHIL TRAVAGLINI '56
JOHN VALENTINO '51
DOM VILLARI '50
HERMAN DOC WATMAN '14
MARTY WEINBERG '55
BENJAMIN MOE WEINSTEIN '21
WALTER WELHAM '25
TAREZ L. WILLIAMS '84
ISAIAH BUNNIE WILSON '67
JAMES WOODY WOODSON '63
MARTY ZIPPEL '39
PHIL ZUBER '30

The Alumni Association honors its outstanding athletes each year by inducting into its Hall of Fame those who have achieved considerable success in their high school careers and beyond.

Five

SOUTHERN'S STARS IN SCIENCE, WRITING, AND EDUCATION

Students who enter Southern are challenged to learn science and mathematics. As a manual trade school, Southern's students learned skills required at that time. When Southern became a multi-faceted school, the curriculum changed to keep abreast of advancements in knowledge. Thanks to the impact of Israel Goldstein on the administrators at Southern, the development of the academic program set the stage for a multitude of incredible accomplishments of Southern's graduates in medicine, science, technology, writing, and pedagogy.

Southern is proud of its numerous scientists, physicians, technicians, writers, researchers, and educators. While Southern's stars in the performing arts are well-known to the larger world, stars in the disciplines in this chapter are less widely known, but their impact is still quite significant. The esoteric and somewhat circumscribed nature of the work of scientists and scholars does not necessarily lead to "household name" recognition, but their impact is powerful and profound nonetheless.

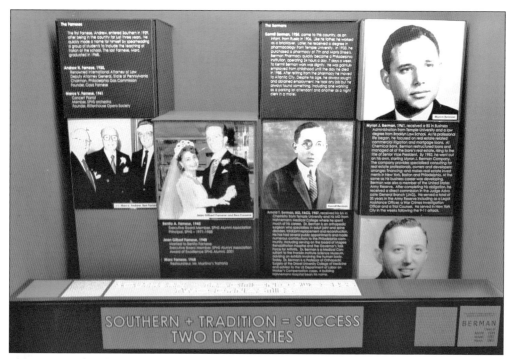

SOUTHERN + TRADITION = SUCCESS
TWO DYNASTIES

The Berman family (Kermit, 1924; Arnold, 1957; and Myron, 1961) is highlighted on the right side of the display case pictured above. The Farnese family is highlighted on the left. Farnese family members include Andrew Farnese (1935), deputy attorney general of Pennsylvania; Marco Farnese (1941), concert pianist; and Benito Farnese (1945), principal of Southern from 1971 to 1988. The Berman family story begins with Kermit Berman, who came to this country from Russia in 1906. He worked as a bricklayer, earned a degree in pharmacology from Temple University, and then opened a pharmacy at Seventh and Morris Streets. Dr. Arnold Berman (1957) received his bachelor's degree in chemistry from Temple University and his medical degree from Hahnemann Medical College, where he spent much of his career. Dr. Berman is an orthopedic surgeon specializing in adult joint and spine disorders. Myron received a bachelor's in business administration from Temple and a law degree from Brooklyn Law School. He focused on real estate–related commercial litigation and mortgage loans. At Chemical Bank, Berman rose to senior vice president.

Dr. Irving Goldschneider (1955) had a major impact on world health in his research. As a pathologist, he helped develop the vaccine against meningitis while in the Army. The vaccine was administered during an epidemic in Brazil in 1971, saving over 10,000 lives. Dr. Goldschneider later taught at the University of Connecticut.

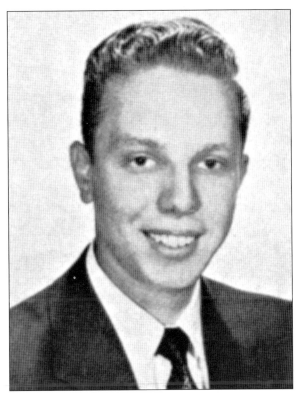

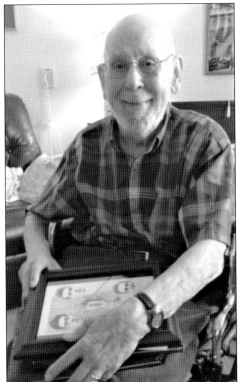

Dr. Alexander "Al" Tulinsky (1947), pictured, is known for his dramatic research into the structure of molecules involved in blood coagulation and fibrinolysis. Tulinsky earned a bachelor's degree at Temple University and a PhD at Princeton University. Other Southern graduates who have made a mark in the medical field include Dr. Angelo DiGeorge (1939), world-renowned pediatric surgeon; Dr. Arnold Fox (1946), creator of the Beverly Hills Diet and author of nine best-selling books; Dr. Vincent Fulginiti (1949), noted expert on pediatric infectious diseases; and Lee Ducat (1950), founder of the Juvenile Diabetes Relief Foundation and the National Disease Research Interchange.

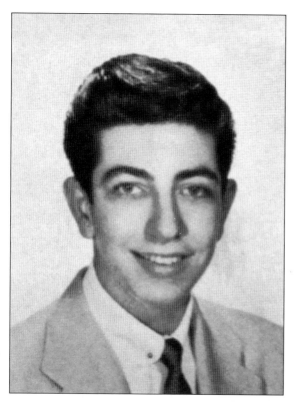

Dr. Charles Profera Jr. (1955) developed satellite antenna products for RCA, GE, and Lockheed-Martin, which made possible, among other things, worldwide broadcasts of Monday night football and other programs. His accomplishments include over 35 technical publications and 15 patents for various antenna components and systems. He was elected to the Space Technology Hall of Fame and the prestigious IEEE Fellow grade.

Steve Milner (1958) stands before an Apollo/Saturn V rocket prior to sending three American astronauts to the moon. Milner is a former NASA public affairs contractor and congressional and public affairs officer for the Norfolk Naval Shipyard. He earned bachelor's and master's degrees in journalism from Penn State. He reported on America's early manned and unmanned space launches to radio stations throughout the United States and produced weekly radio programs about space activities. He interviewed astronauts, engineers, and other support personnel who made space flights possible.

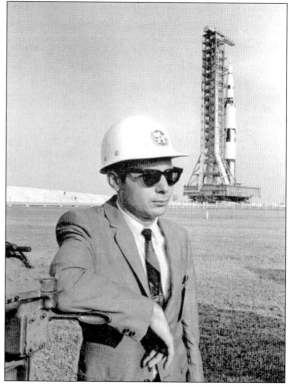

In the world of science and science fiction, Ben Bova (1949) shines as a gifted, prolific writer, with over 130 science articles and science fiction novels. Shown at right at his induction into the SPHS Cultural Hall of Fame, as presented by Gene Alessandrini, Bova served as a former editor of *Analog Science Fact & Fiction*. He won six Hugo Awards for best professional editor. Bova's awards include the Lifetime Achievement Award of the Arthur C. Clarke Foundation in 2005. His novel *Titan* won the Campbell Memorial Award for best science fiction novel in 2006. In 2008, he won the Robert A. Heinlein Award.

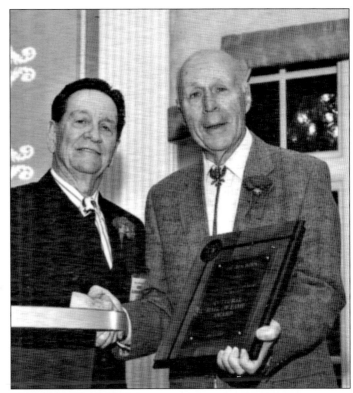

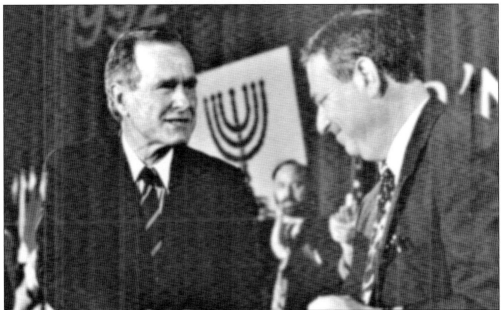

Dr. Sidney "Sid" Clearfield (1957) is seen with Pres. George H.W. Bush as head of B'nai B'rith International. Dr. Clearfield served as executive vice president of B'nai B'rith International in Washington, DC, and international executive director of the B'nai B'rith Youth Organization. He also served as chief operating officer responsible to the president of Jewish Educational Service of North America in New York.

Tony Evangelisto (1958) is shown at left during one of his teaching and consulting assignments in Saudi Arabia. He earned a bachelor's degree in English at LaSalle College and a masters and doctorate in English education at Temple University. Dr. Evangelisto taught at Trenton State College (now the College of New Jersey) for 36 years, retiring as full professor. He has taught and consulted extensively in Asia, the Middle East, South America, Africa, and Europe. In Kuwait, he was hired as consultant to the Sultan International Academy in Kuwait City.

A major figure in psychological counseling is James L. Framo (1940), internationally renowned pioneer in family therapy. He is a distinguished professor at United States International University, San Diego, and founder of the American Family Therapy Association, with over 60 publications in the field, including *Intensive Family Therapy*, *Explorations in Marital and Family Therapy*, *Selected Papers of James L. Framo*, and *Family Therapy*.

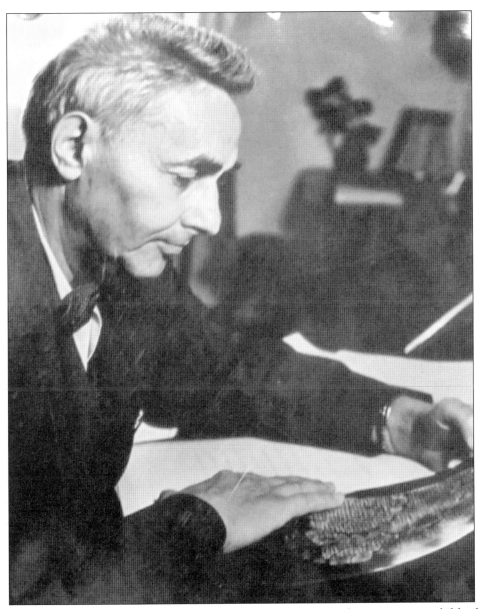

Samuel Noah Kramer (1915) is another marvelous example of an immigrant child who succeeded brilliantly. He achieved fame for his studies on Assyrian and Sumerian languages and cultures as a professor at the University of Pennsylvania. Kramer was born in Zhashkiv, near Uman in the Kiev Governate, Russian Empire. In 1905, as a result of anti-Semitic pogroms under Czar Nicholas II, his family emigrated to Philadelphia, where his father established a Hebrew school. His birth name was Simcha, and after graduating from Southern in 1915, he enrolled at Temple University and later entered the University of Pennsylvania, earning his doctorate in 1929. In 1930, Kramer participated in two digs in Iraq—first at Tell Billah in the north and then Tell Tara on the site of ancient Shuruppak; at this site, his work turned up a quantity of tablets, leading to his being invited to the University of Chicago to compile an Assyrian dictionary. Four years later, he won a prestigious Guggenheim fellowship and went to Istanbul to investigate the Nippur tablets.

Prominent sociologist Dr. Robert King Merton (1925), born Meyer Schkolnick, rose from humble beginnings as the child of a working class Eastern European Jewish immigrant family. He won a scholarship to Temple University and a fellowship to Harvard University for graduate work in sociology. He became associate professor and then professor at Tulane University. In 1941, he became assistant professor at Columbia University, rising to full professor. Merton has received myriad awards and honors, most notably the 1994 Medal of Science Award. Prizes have been awarded him by the American Council of Learned Societies, the National Institute of Medicine, the American Academy of Arts and Sciences (Talcott Parsons Prize for Social Science), the Memorial Sloan-Kettering Cancer Center, Society for Social Studies of Science (Bernal Award), and American Sociological Association (Common Wealth award and Career Distinguished Scholarship award). He also was a MacArthur Prize fellow.

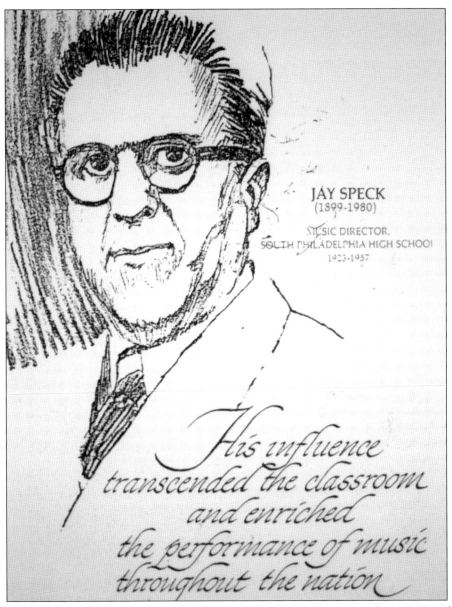

JAY SPECK
(1899-1980)

MUSIC DIRECTOR,
SOUTH PHILADELPHIA HIGH SCHOOL
1923-1957

His influence transcended the classroom and enriched the performance of music throughout the nation

Jay Speck (1910) studied under John Philip Sousa and began teaching at Southern in 1923. Southern's musical successes originated with the influence of Dr. Speck. Dr. Sidney Rosenfeld said of him, "We knew him as a short, barrel-chested man in his mid-50s, red-faced and with an unruly shock of graying dark hair. Either he had been born an eccentric or, to pedagogical ends, had played the role so long that be became one for real." Speck became a legend, and his Southern musicians held chairs in major orchestras across the country. Rosenfeld added, "When Frankie Avalon ventured to audition for a trumpet spot in the orchestra, Maestro Speck dismissed him after the first few notes: 'Son, you'll make a good plumber. Come back in a year.' Chastened, Avalon did that and was accepted." Among Speck's last protégés were Broadway conductor Alfonse Cavaliere and Philadelphia Orchestra members Leonard Bogdanoff, viola; Joseph Lanza, violin; and Donald Montanaro, clarinet.

H. Patrick Swygert (1960), president emeritus of Howard University, is pictured above with former president Barack Obama at a Howard University commencement. Swygert was a young man from an urban environment who rose to great heights by virtue of his intelligence, hard work, and drive to succeed. His high school yearbook profile gives a sense of a man who wished to serve others. He graduated from Howard University and later earned a law degree from Howard Law School. He served as executive vice president of Temple University and as president of the State University at Albany. Pictured below is Samuel S. Vaughn (1945), former president and editor-in-chief of Doubleday.

Dr. Stanley Weintraub (1946) had a highly successful career as historian and biographer. He was an expert on George Bernard Shaw. After graduating from Southern, he attended West Chester State Teachers College and earned a master's degree in English at Temple University. He received a commission as a second lieutenant in the US Army and served with the 8th Army in Korea, receiving a Bronze Star. His military background clearly established his ability to write about military history and matters with genuine authority. After the Korean War, he earned a doctorate at Penn State, where he taught for his entire career and has numerous publications.

South Philadelphia High School Alumni Cultural Hall of Fame

JULES ABRAMS '46
MARIAN ANDERSON '21
DR. AARON BANNETT '39
DR. SAMUEL BELLET '18
HON. EMANUEL BELOFF '21
DR. ARNOLD BERMAN '57
MYRON BERMAN '61
ROBERT M. BERNSTEIN '11
DR. BEN BOVA '49
MOE BROOKER '59
PROF. JOSEPH BROWN '26
LESLIE BURRS '70
ABRAHAM D. CAESAR '18
DR. ELAINE CAMEROTA '57
HON. MATTHEW
 CARRAFIELLO '64
JESSE CECI '41
ROBERT CERULLI '55
HON. NICHOLAS CIPRIANI '35
DR. ABE CLEARFIELD '45
DR. SIDNEY CLEARFIELD '57
ARTHUR G. COSENZA '42
VALENTINO CIULLO '51
ALFRED D'ANGELO '27
JOSEPH DAUGHEN '52
DR. ALAN DECHERNEY '59
DR. JOHN J. DELUCCIA '53
DR. ROCCO DEMASI '61
DR. CARMELA F. DERIVAS '40
RICHARD DIADAMO '62
G. FRED DIBONA '68
HON. ALFRED J. DIBONA '53
JOHN DICIURCIO 45
DR. FRANK DIDIO '23
DR. ANGELO DIGEORGE '39
MAX DIJULIO '37
DR. GEORGE DIPILATO '57
DR. ANTHONY DIPRIMIO '51
FRED DISIPIO '44
JEROLENE BIZZARO DREFS '52
DR. LEE ZITOMER DUCAT '57
DOROTHY ADLER EISENBERG '46
DR. ANTHONY EVANGELISTO '58
ANDREW FARNESE '33
BENITO A. FARNESE '45
MARCO V. FARNESE '42
LOUIS FISCHER '14

PAULINE FISHER '52
HARRY FORMAN '40
ANNA LELII FORTE '48
DR. EDMUND J. FORTE '49
DR. ARNOLD FOX '46
MORTON S. FREEMAN '30
DR. VINCENT FULGINITI '49
DR. JOSEPH GAMBESCIA '35
DR. HARRY GARFINKEL '50
FRANK GASPARRO '27
DR. WILLIAM GEFTER '32
EDWIN GERBER '53
DR. JAMES GIUFFRE '27
DR. W. LEON GODSHALL '14
DR. HARRY GOLDBERG '35
DR. IRV GOLDSCHNEIDER '55
DR. ISRAEL GOLDSTEIN '11
DR. NORMAN GOODMAN '47
CHARLIE GRACIE '54
DR. SID GROBMAN '52
PROF. LOUIS GROSSMAN '15
WILLIAM "WILD BILL" GUARNERE '42
FRANK GUARRERA '42
GEN. DONALD L. HARDY '26
LT.COL. GEORGE E. HARDY '42
EDWARD "BABE" HEFFRON
GEN. GEORGE HONNEN '15
PATTY JACKSON '81
DR. SAUL JECK '49
HON. HARRY E. KALODNER '12
HON. LYDIA Y. KIRKLAND '70
DR. SAMUEL NOAH KRAMER '15
MORRIS A. KRAVITZ '18
HARRY G. KUCH '22
CHARLES LAGROSSA '54
DR. SIMON LANE '42
JOSEPH LANZA '51
LOUIS LANZA '54
MARIO LANZA
FRANK LEONE, SR. '57
DR. ALAN LEVY '50
ROBERT MARCUCCI '47
DANTE MATTIONI '48
THOMAS R. McCURDY '58
DR. FRANK MELE '47
JOHN M. MERCANTI '62
ROBERT K. MERTON '28

DR. HENRY I. MILLER '64
HON. CHARLES MIRARCHI, JR '41
JOHN NELSON '55
HON. RUSSELL NIGRO '64
DR. PETER NOCELLA '62
DR. TESSIE BREGMAN OKIN '36
DR. A. M. ORNSTEEN '11
ARNOLD R. ORSATTI '33
DR. DORIS COHEN PAISS '47
DR. CAROLYN P. PARKS '72
ROY T. PERAINO '46
DR. VINCENT PERSICHETTI '33
ANTHONY F PINNIE '49
Dr. CHARLES E. PROFERA '55
NICHOLAS RAGO '60
MAJ.GEN. DANIEL A.
 RAYMOND '37
MICHAEL ROCCO '43
RICHARD [DiCICCO] ROME '49
RICHARD I. RUBIN '22
DR. ALVIN ROSENFELD '56
DOMINIC SABATINI '58
ANTHONY SACCA '69
DR. JOHN F. SANTORE '59
VINCENT SCARZA '52
ABE SCHWARTZ '29
ROBERT SEBASTIAN '25
THOMAS SEBASTIAN '63
DICK SHEERAN '57
JERRY SIANI '53
DR. GUS SPECTOR '61
DR.WILLIAM E. STAAS, JR '54
DR. KENNETH STEIN '61
SANDY AUSTIN STEIN '63
JOSEPH STEFANO '40
H. PATRICK SWYGERT '60
ARTHUR TAYLOR '76
FRANK TENAGLIA '92
DR. ANTHONY TRIOLO
DR. ALEXANDER TULINSKY '47
DR. MAX TRUMPER '14
DR. JOHN R. VANNONI '44
SAMUEL S. VAUGHAN '45
WILLIAM VENUTI '42
DR. STANLEY WEINTRAUB '46
DR. JERRY ZASLOW '43
NAOMI WEINTRAUB ZASLOW '46
ANTHONY ZECCA '38

Each year, the SPHS alumni association honors graduates who have achieved distinction in their respective fields by inducting them into the cultural hall of fame. Their accomplishments are recognized as having contributed significantly locally, nationally, or internationally.

Six

THE SECRET OF
SOUTHERN'S SUCCESS

From a sociological standpoint, using Southern graduate and world-renowned sociologist Robert Merton's concepts, Southern evidences a social climate that is highly conducive to success. Highly experienced and successful psychological counselor Carol Evangelisto was asked to make inferences about why Southern has been so successful over the years. She is a former elementary schoolteacher and has worked professionally in the psychological counseling field. Through her work with clients, she has developed a keen sense of the forces and influences that shape people's lives and either enhance or impede their success. Her background in education and in human development provides a balanced, objective purview of Southern and how it has helped students achieve remarkable successes.

Evangelisto explains, "For nearly 30 years, from the first time I met him, I have been captivated by my husband's many stories about the famous 'stars' of South Philadelphia High School, which were primarily well-known luminaries of the performing arts. I was also struck by his deep and enduring gratitude to the school and for the education he received there. As I got to know him, I realized that Southern truly had helped to define him as a person; his experiences there were important and integral parts of his life, and they continue to be so to this day. In his career as a beloved college professor whose specialty focus has been the training of new teachers, he has also shared stories of his experiences at Southern with legions of budding high school teachers. He has told them about Mrs. Mary Lippmann, his Latin teacher at Furness Junior High School whom he credits with turning his life away from the street gangs of his Philadelphia neighborhood toward finding refuge in books and study. Her high standards and belief in him were pivotal in his becoming a successful student. He has also told them about an English teacher, Dr. Constance Rosenthal, who mentored him in his role as editor of the school paper, and about so many other dedicated educators who helped to shape his future. As I began to attend annual reunions and awards banquets, I observed the affection and camaraderie the attendees continued to have for each other, and I began to sense the pride they all felt when one of their own had become successful."

One might ask "what could a Jersey girl know about South Philadelphia High School?" Clearly, Carol Evangelisto knows quite a bit, as she further explains, "Each year, I heard more and more phenomenal success stories, and each year, I wondered to myself how one school could account for so many of these. Was it the neighborhood and the mix of races and ethnicities for which South Philadelphia is known? Was it that many of the students were the first generation of kids born to immigrant families? Was it their strong desire to succeed, to do better than their parents? Was it a sense of connection to each other and to their community? Could it be attributable to a zeitgeist? Was it something in the South Philly water? It wasn't until I sat with my husband at the alumni hall of fame induction banquet in 2015, listening to the virtuoso violinist Louis Lanza serenade his alumni classmates, that I just couldn't contain myself. His music moved me to tears that day, and I whispered to my husband, 'You have to write a book.' "

Evangelisto continues, "Thus began my minor involvement in helping to illuminate and preserve forever the 'Stars of Southern High.' Tony asked me to provide an 'outsider's perspective' to shed light on the phenomenon that is South Philadelphia High School. I do not hold myself to be a social scientist or researcher, so what I have written here is purely speculation based on what I have observed and learned in my 25-year career as a psychotherapist. When students begin college, many bring with them a history of experiences, circumstances, and issues that could potentially interfere with their success . . . adversity seems to be a motivator." Pictured at right is Mario Lanza's house, and below is Marian Anderson's home.

South Philadelphia High School
Alumni Association Executive Committee 2015-2016

Pictured here is the SPHS Alumni Executive Committee. The alumni supports Southern in many ways. The major form of support is through scholarships given to students to pursue further education.

It is impossible to overlook one of the additional ingredients in the recipe for success that Southern has formulated over the years, and that is the impact of the community known as South Philly. South Philly is a phenomenon that defies description, but its impact and influence are profound. Many commentaries have attempted to capture the essence of South Philly, but none have conveyed it with such vibrancy as the piece that follows from Marc Adelman, pictured at right. Below is the Melrose Diner. Adelman, the indispensable and indefatigable archivist of the SPHS Alumni Association, has shared an item he has written that is priceless because it captures the essence of South Philly, capturing a sense of what has contributed to many of the success stories shared earlier.

Adelman entitles this piece "I Am South Philly:" "My name is South Philly. I am a row house, white marble steps and the lamplighter; a narrow one-lane street of clean swept sidewalks, ugly utility wires strung with some kind of purpose; tiny retail stores of imaginable necessities and the unimaginable luxury of Termini's Bakery. I am hoagie shops. I am Pat's Steaks. I am the Melrose Diner, the Dugout and Marra's Pizza. I am Municipal Stadium and the Navy Yard. I am The Lakes, Marconi Plaza, the Dumps and the Neck. I am St. Agnes, Methodist, Mt. Sinai hospitals and St. Martha's Settlement House. I am Moyamensing and Passyunk Avenues, Two-street and the Mummers. I am 7th Street shopping and the Italian Market. I am the C Bus, the Broad Street subway and trolley cars. I am schools. I am Francis Scott Key Elementary school; Thomas Jr. High and South Philadelphia High School; the red and black; the Rams; The School of the Stars; Avalon, Fabian, Chubby Checker and Charlie Gracie; Marian Anderson, Mario Lanza, Eddie Fisher, Jack Klugman, Joey Bishop and so many more . . . it's embarrassing to be so prideful." Pictured is a local bodega, common in South Philadelphia.

From the Four Corners of Broad and Jackson . . .

they covered the earth.

"I Am South Philly" continues: "I am the corner luncheonette and Two-cents Plain, Black & White Milkshakes and add the malt for a nickel. I am alleys with wooden and wrought iron fences that almost touch each other's outstretched arms and were never taken seriously for privacy but as an access to community. I am professional services that would consider a home visit as essential as an office visit. I am street vendors as an extension of the old to the new; water ice, yumyum, snow balls, penny pretzels, the ice man and the Javelle water man."

"I am movie theaters; the Ideal, Grand, Jackson, Savoia, Broadway, Colonial, and the South Philly Drive-In. I am corner taprooms and Moxie's Pool Hall. I am churches and synagogues; lots of churches and synagogues. I am street games; Pimple Ball, half-ball, stick-ball, wire-ball, hose-ball, pony-ball, buck-buck, and Chink. I am working class, blue collar, never poor, only rich in morality, family, and community. I am a child with the curiosity and hope only a child could wish for. I am a neighborhood. I am a town. I am a city. I am a neighborhood more than a city many times over. I am family. I am South Philly. 'The best day of the rest of my life was when I returned to live in South Philly.' I smiled down on this boy. I welcomed him home as an old soul who left lifetimes ago and now has returned for one more time to take in the joy of the life that I offer and the meaning of life through every experience perceived. He's teachable. I can nurture him because he gets it. He gets the meaning and the value of relationships through the sense of community I offer." Above, the Whitman String Band entertains spectators near Southern High during Old South Philadelphia Week festivities. Below, the appeal of the Mummers attracts people from all over the world, as seen in this photograph of Ebtissam Ammar, native of Egypt, attending her first Mummers Parade. (Above, courtesy of the Urban Archives at Temple University.)

Street scenes in South Philadelphia are replete with street vendors selling soft pretzels and water ice, as shown above. A water-ice vendor just outside of the school building serves a local specialty in lemon and cherry flavors. Below is a typical scene of Southern students playing handball in the cool shade of the old school building. South Philly is a star in its own right, shining in the galaxy of stars that Southern High School has given to the world. Those who have benefitted from the experience of growing up in South Philly and receiving a world-class education at South Philadelphia High School are truly grateful for what we have been given.

It is fitting and proper that this praise returns to the school and the teachers who are vital in preparing children to succeed. Above, librarian Kathleen Butler-Hayes is seen by her office. Below, students are working on research projects under her supervision. Southern is most fortunate to have had a legion of highly effective administrators. The current administration presides over an incredibly difficult and complex task in an environment where charter schools have drained substantial financial resources and have lured away many students. The tragic result is that public schools no longer serve the varied populations they once did. The students at Southern today are much like their predecessors: immigrants, poor, ethnically and racially diverse, and challenged by language, health, and social concerns. Southern has been designated as a community school and provides social services as well as education to students and their families.

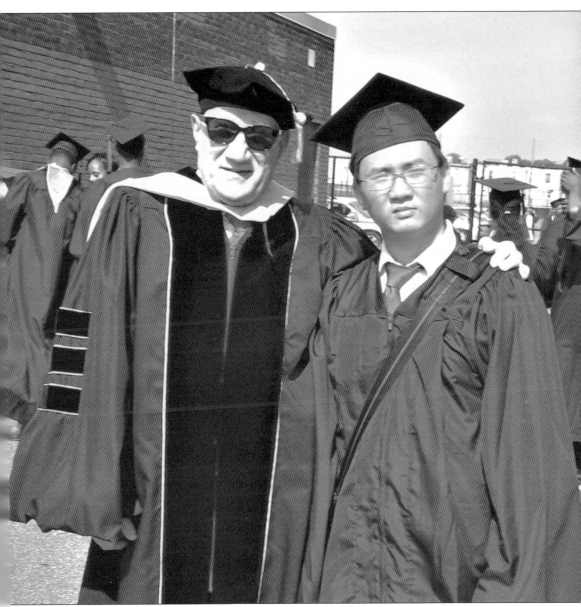

One experience the author had a short time ago involves a student he calls "Norman." "I was leaving the archives room in the library and was halfway down the hallway when a young man ran up to me and frantically asked, 'Dr. Tony, my friend needs help with his project and please, would you come back and help?' How can any educator decline such a request? I immediately turned around, went back into the library, and quickly learned that Norman had some excellent ideas but was challenged enormously by language. After reading his work on the school laptop, I asked him to e-mail it to me so I could go through it more carefully and make recommendations. We exchanged several e-mails in the process, and the result was that he did an exceptional job presenting his project to a panel of judges, which included me as a guest judge. Norman graduated and proudly shared his plan with me on graduation day to go to college and study business so he could help immigrant families."

Happily, Southern principal Kimlime Chek-Taylor, pictured at left, is up to the challenge. She, an immigrant from Phnom Penh, Cambodia, can identify with and respond appropriately to the needs of students. She points out what she believes is a limitation in her personal background— her background is in elementary education. However, this is exactly what Southern needs today because her level background disposes her to focus on the child first and to create a supportive learning environment for students. Her efforts in the school have brought positive energy to every part of the building. Her assistant principal, Nina Gavula, seen below, though diminutive in stature, is a very strong leader who has earned the respect of students and staff alike with an approach to getting things done promptly and properly.

Southern benefits from the work of an Instructional Leadership Team, which serves in a support role and helps to formulate policies and decisions to foster the educational programs. Additionally, the office staff, led by Arlene Pagan, pictured at right, helps to provide positive and effective gate-keeping in the front office. Pagan's bilingual ability and sincere, friendly manner have helped many students and their families from day to day. John Kenney, seen below, helps maintain Southern's physical plant to keep it safe and hospitable.

Sgt. Thomas Terry, left, leads a cadre of school police who maintain order in the building and on the premises. He is a graduate of Southern and has recently been inducted into Southern's Athletic Hall of Fame in recognition of his performance in basketball and football. School police are present in all parts of the building to assure that students are able to attend to their studies without having to contend with disruptions from inside the building or from the streets outside. Seen below is Officer Charles Boller, who greets people entering the building.

As time has moved on, the student population at South Philadelphia High School has remained diverse, with a dramatic increase in the number of Asian immigrants. At right, Janelle Harper leads the newly designated community school created to support families who are struggling to adjust to a new country. Harper oversees a group of "Partners," local social agencies who provide services to families, and has done a superb job of making provisions to assist children and their families with a clothing store and food pantry where students can shop for items of their choice without needing to pay for them. Doris Burney (below), the dean of students, has had a positive and profound influence on Southern's students.

To help students, Southern has initiated a ninth-grade academy originally led by Crystal Edwards, who has moved on to become principal at another school. Tamika Jones-Tabbs, pictured at left, works with students in the ninth-grade academy, monitoring attendance and performance to help them progress satisfactorily toward graduation. Gail DeBerardinis, seen below, directs activities of the Torch Chapter of the National Honor Society.

Southern's exemplary athletic traditions are spearheaded by Frank Natale (right), originally from the staff of Bok Vo-Tech, whose enthusiasm and goodwill permeate the halls of the school and the airwaves through his daily announcements. Jeffrey Judge (below), a math teacher and member of the Instructional Leadership Team, still manages to find time as a basketball coach.

Denise Powell (left) is the guiding light of a career and technical education program in graphic arts. She has produced posters for the school portraying famous Southernites such as Marian Anderson and Mario Lanza as she helps prepare students for careers in graphic arts. Joseph Imbesi (below) is a premier science teacher whose passion for science and for teaching have made significant contributions to the academic preparation of students at Southern.

The individuals pictured here provide exceptional guidance and support in vital aspects of education at Southern today. At right is Joseph Brazino, who guides the special education programs and activities at Southern. He advocates on behalf of special needs students as a member of the Instructional Leadership Team. Below, Barry Hertzberg is a computer technology and photography expert whose work has an impact throughout the school. Hertzberg creates Southern's annual yearbooks, not only in their organization and design but also all of the photography. Many of the images in this book are courtesy of Hertzberg.

At left, Shelly Lipscomb has the daunting task of organizing all of the standardized testing that occurs at Southern, and is responsible for securing test materials and coordinating all standardized testing activities at Southern. Below is Jennifer Bianco, who provides guidance to the language-arts curriculum, a key component in academic and career education programs.

Christine Partito (right) is the career awareness specialist at Southern who provides numerous activities to enable students to discover career opportunities and to prepare appropriately to enter areas of employment suited to their interests and abilities. Partito organizes visits to various educational establishments and brings speakers and events to the school to assist students in their future planning. Henrietta Patrick (below) is now retired but served students at Southern for many years as an ESL teacher, helping students to overcome language barriers. Patrick's skills as a teacher and her encouraging manner in working with students are still remembered.

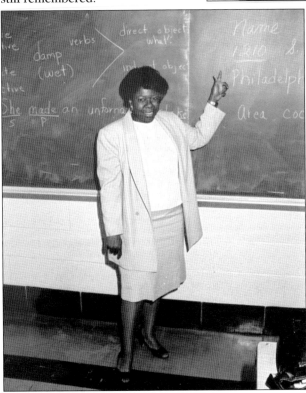

Pictured above is Clintonia Harmon, who greets and guides visitors. At left is Karl Murset, the roster scheduling wizard. Murset has the responsibility for scheduling all classes at the school and serves on the Instructional Leadership Team to coordinate with administrators and departmental leaders.

Southern's history is that of a public school situated in South Philadelphia that drew from many different neighborhoods, each with the requisite elementary and junior high schools. In the organizational scheme of the time, elementary schools served kindergarten through sixth grade, junior high schools served grades seven through nine, and high schools served grades 10 through 12. The class from Furness Junior High School seen here graduated in January 1955 and entered Southern in the "old" building; they were the last class to enter the old building before it was demolished and replaced by the existing structure today.

Pictured here is Audrey Nock, whose influence through her work in special education is positive and profound.

SOUTH PHILADELPHIA
HIGH SCHOOL

ALUMNI ASSOCIATION
ARCHIVE

"RESERVING THE LESSONS OF HISTORY
FOR THE BENEFIT OF FUTURE GENERATIONS!"

The history of South Philadelphia High School is a continuum that extends from the early 1900s to the present day. The school has been known as "the School of the Stars" because of the large number of high-profile stars in popular and classical music and in television and Hollywood productions. A picture of Dr. Gus Spector is included here to show that students at Southern often combine talents from more than one skill set. Dr. Spector is a highly-respected former chief of urology at Phoenixville Hospital who was a member of Southern's concert and marching bands and was a member of the All-Philadelphia High School Orchestra. One purpose of this book has been to honor those very stars. A second has been to identify and acknowledge Southern's many stars in other fields of endeavor who are not as widely known as the high-profile group. A third has been to acknowledge and honor the individuals and historical influences that have made this school the prodigious success story that it has been.

This poster was produced as Southern celebrated its 100th anniversary. It proclaims the great pride that Southern alumni have for their school. Photographs of Southern students from the girls' school and photographs of athletes from the boys' school are shown in the upper portion; the bottom shows the cutting of the ribbon to open the current building, with an image of the original building on the right. *Cent'anni* translates from Italian as "one hundred years," but the term is also used by Italians in toasts; in such situations, the toast wishes others 100 years of health, happiness, and prosperity. This poster thus not only celebrates the past hundred successful years of Southern's existence, but also wishes the school an additional century of success.

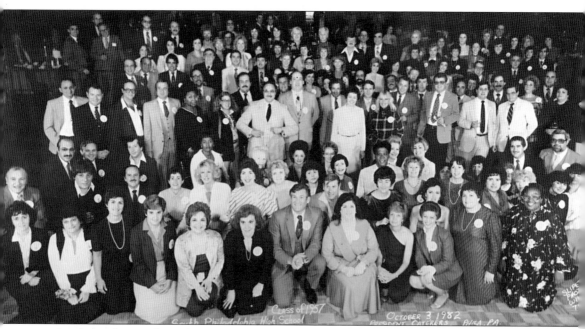

Southern alumni show their gratitude to the school that prepared them so well for life by attending class reunions and by supporting the SPHS Alumni Association. Shown here, the class of 1957 is gathered for a group photo at their 25th reunion.

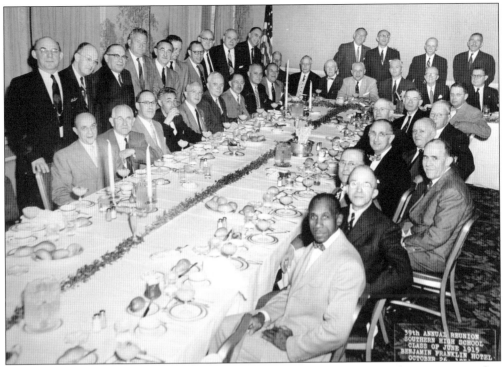

Southern's graduates remain loyal to each other and to their school many years after graduating. Above is the class of 1915 celebrating its 39th reunion in 1954; below is the class of 1920 celebrating its 45th reunion in 1965.

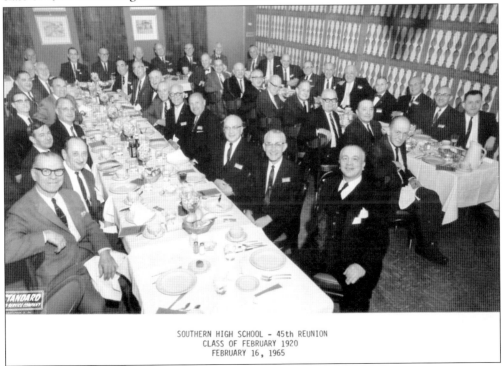

SOUTHERN HIGH SCHOOL - 45th REUNION
CLASS OF FEBRUARY 1920
FEBRUARY 16, 1965

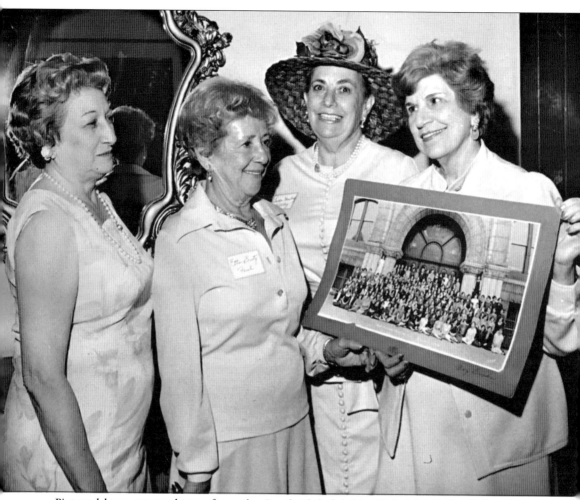

Pictured here are graduates from the South Philadelphia High School for Girls, admiring the photograph of their 1926 graduating class taken at the school's entrance. From left to right are Anna Liscio, Etta Paul, Bertha Goldberg, and Anne Shendrov. (Courtesy of the Urban Archives at Temple University.)

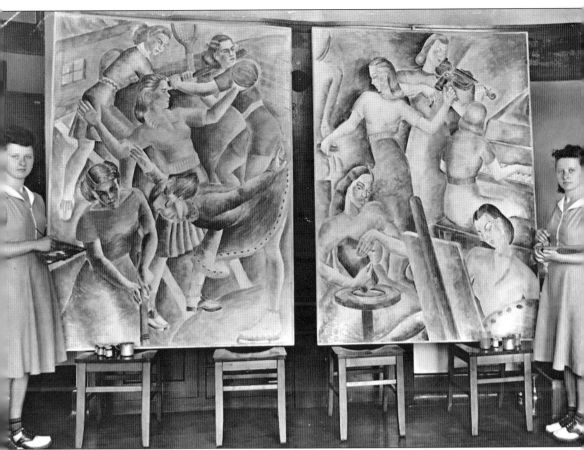

Twin sisters Evelyn and Elsie Morkren stand with murals that they painted and donated to the school. Evelyn is on the left with her mural "Women in Athletics," and Elsie is on the right with "Women in Music." (Courtesy of the Urban Archives at Temple University.)

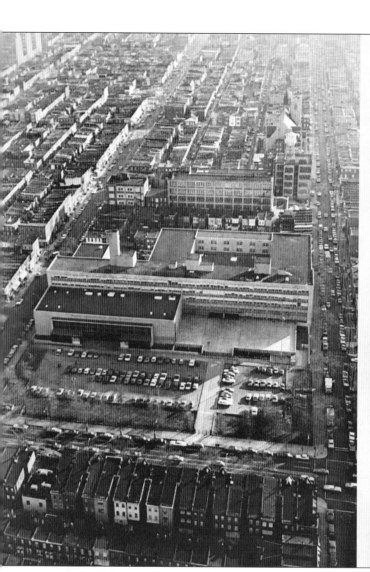

Alma Mater

To you, Southern High, we sing,
Your praises forever ring.
Your sons and daughters pledge to y
Their faith anew,
Their honor true.
Wherever our paths may lead,
We're with you in thought and deed
Dear Alma Mater, Southern High,
It's just farewell, but not goodbye.

(Leon Margarite, Alfred Ostrum
George Paravicine, John Shuman)

Southern is seen from the air, nestled in its surrounding neighborhood of row homes so typical of South Philadelphia. Southern's logo is displayed along with the words of the alma mater.

122

Southern has given the United States six admirals and six generals, along with an abundance of officers, ranking from second lieutenant to colonel. Many of Southern's military heroes have been inducted into the SPHS Alumni Cultural Hall of Fame. Pictured here is Gen. George Honnen (right) receiving his induction plaque from David Dabrow of the alumni association.

Bruce Springsteen's song "Glory Days" evokes images of early successes in life, and so much of a school's heritage is built upon the glory days of its star athletes. Anthony Coletta, pictured at left, is commemorated below along with his teammates Tulinsky (his name was misspelled in the game program) and Carlozza. These star athletes were pivotal in the high school championship that was shown on newsreels around the world.

ANDREW TULINSKE
Quarterback

JOE CARLOZZA
Back

The glory days of Southern's illustrious past include so much more than sports, as earlier chapters of this book have illustrated. In this picture, honor students from the class of 1955 provide a testimonial to the prodigious ability of Southern's students. From left to right are (first row) Bruce Paul, Ronald Moccia, Charles Profera, Robert Alessandrini, Gene Alessandrini, Anthony Fasolo, Bernard Appelbaum, Irving Goldschneider, Harold Balshem, Edwin Soslow, Harold Greenberg, and Raymond Sozio; (second row) Joseph Pritta, Anthony DeGregorio, Alfred Cortese, Martin Mikelberg, Herman Eisen, Paul Cilione, Hercules Michael, Louis Frank, Harvey Young, Alfred DiMarino, John Sebastian, Robert Richi, Nicholas Simone, and Nicholas LoCastro; (third row) Thomas DiRenzo, Leonard Bello, Anthony Infante, Victor DiNubile, Carl Ortell, Anthony Manno, Conrad Heins, Bernard Sickelstiel, Paul Formentos, Harry Carrozza, and William Griffis.

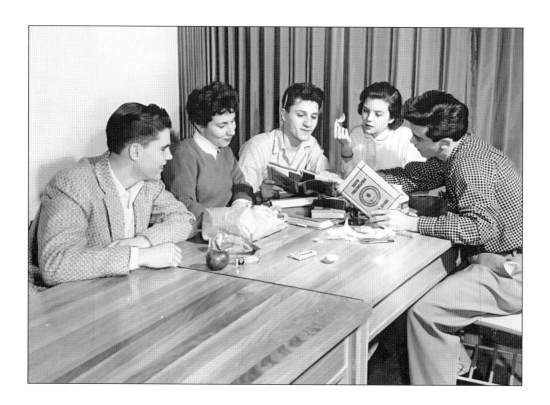

Pictured above are Southern students from the past studying together as they enjoy lunch. Below, current students in the Junior Reserve Officers Training Program are seen with Philadelphia mayor Kenney (fifth from right), former principal Otis Hackney (behind Kenney), and current principal Kimlime Chek-Taylor (second from right) upon Mayor Kenney's visit to Southern. (Above, courtesy of the Urban Archives at Temple University.)

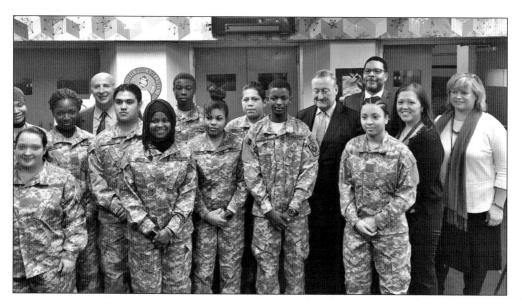

Pictured here is the entrance to South Philadelphia High School with Marc Adelman, the SPHS Alumni Association's archivist, representing the nexus between Southern's past and future. The origin of this project was Louis Lanza's virtuoso performance of a touching Italian melody entitled "Non Ti Scordar Di Me." Lanza is pictured below. It is the author's hope and that of the South Philadelphia High School Alumni Executive Committee that the memory of the school, its former students, its administrators and teachers, and South Philadelphia itself is preserved and honored. Lest we forget, non ti scordar di me.

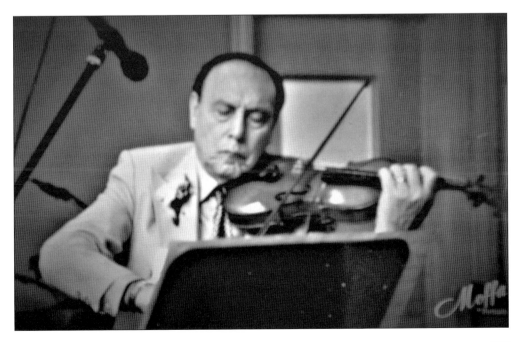

DISCOVER THOUSANDS OF LOCAL HISTORY BOOKS
FEATURING MILLIONS OF VINTAGE IMAGES

Arcadia Publishing, the leading local history publisher in the United States, is committed to making history accessible and meaningful through publishing books that celebrate and preserve the heritage of America's people and places.

Find more books like this at
www.arcadiapublishing.com

Search for your hometown history, your old stomping grounds, and even your favorite sports team.

Consistent with our mission to preserve history on a local level, this book was printed in South Carolina on American-made paper and manufactured entirely in the United States. Products carrying the accredited Forest Stewardship Council (FSC) label are printed on 100 percent FSC-certified paper.

MADE IN THE
USA